IMAGES
of America

ROSEVILLE

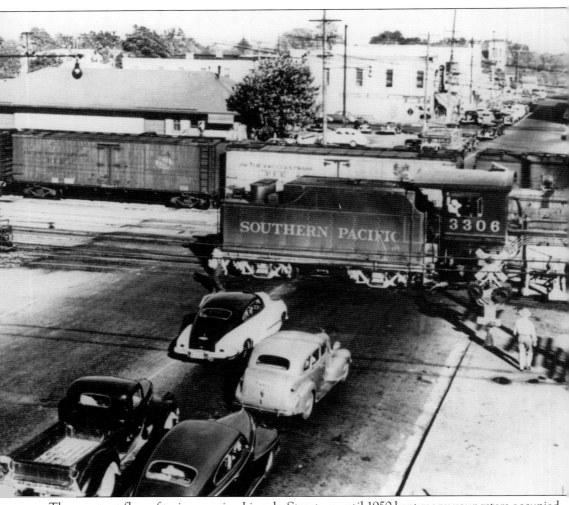

The constant flow of trains crossing Lincoln Street up until 1950 kept many youngsters occupied with counting the cars as drivers waited for the tracks to clear. The Seawell Underpass replaced the Lincoln Street crossing when Washington Boulevard was built underneath the railroad tracks in 1949. (Roseville Historical Society Photograph Archives.)

ABOUT THE COVER: The Roseville shop crew and engineers pose on a steam engine on the Roundhouse No. 2 turntable in 1927. Pictured are Woodrow Lee, Mike Kolak, Louie Guisti, Tom Curtain, Jim Pellit, Jim Carl, Earl Simmons, Andy Leighe, Jim Crowder, Louie Hudson, John Smith, F. Boyer, Brick Paolini, R. Pellit, Glen Selfridge, Dick Layton, Milo Opich, Mel Layton, Bert Shehan, R. Boyer, R. Benedetti, Kenneth Falkner, George Wolf, and E. Coogan. (Roseville Historical Society Photograph Archives.)

IMAGES
of America

ROSEVILLE

Roseville Historical Society

ARCADIA
PUBLISHING

Published by Arcadia Publishing
Charleston SC, Chicago IL, Portsmouth NH, San Francisco CA

Printed in the United States of America

Library of Congress Control Number: 2009920006

For all general information contact Arcadia Publishing at:
Telephone 843-853-2070
Fax 843-853-0044
E-mail sales@arcadiapublishing.com
For customer service and orders:
Toll-Free 1-888-313-2665

Visit us on the Internet at www.arcadiapublishing.com

This book is dedicated to the community of Roseville.
The Roseville Historical Society is dedicated to
preserving and promoting the history of Roseville.

The rose symbolizes the humble roots of what is now the City of Roseville.

CONTENTS

ACKNOWLEDGMENTS

The Roseville Historical Society (RHS) would like to thank all those who assisted with the collection of pictures in this book. This project would not have been successful without their assistance in enlarging the photograph archives of the society. Special thanks go to Christina Richter, who was willing to take her laptop into homes to scan photographs, and to Christie Hooker, who scanned photographs for the society's collection. Thanks to the Bravo, Fiddyment, Eernisse, Astill, Emerson, Rieder, Perry, Wittsche, and Haynes families who donated historical family photographs to the scanned archives of the RHS. Thanks also to Leonard "Duke" Davis, Placer County Archives, Roseville City Library History Collection, and Art Sommers, who allowed the use and archiving of their photographs. Some of the text for this book relied on published books and materials by Duke Davis, the City of Roseville, the *Press-Tribune* and *Sacramento Bee* newspapers, as well as other archived materials in the Carnegie Museum. The most precious insights have been from the stories and memories that have been shared by longtime Roseville residents. A big thank-you goes to Christie Hooker, who spent many hours at the computer putting the pictures in the right order for the text that had been written, for checking facts and researching, for her many suggestions, and her smiles. We have done our best to get the facts and dates recorded correctly, but there could be some errors that were missed. The purpose of this book was to tell the history of Roseville accurately through unique and never-before-seen photographs, as well as with interesting and forgotten tidbits from the past. You may recognize some of the tried and true pictures that have been seen many times before, but they are priceless and just could not be replaced. It has been wonderful looking back on the history of Roseville, and learning some history that we might not have otherwise known. Thanks for the memories!

Phoebe Astill, Board President of the Roseville Historical Society

NOTE: All of the images used in this book are from the recently enlarged Roseville Historical Society Photograph Archives.

ROSEVILLE'S ROOTS

Before it was even named, the land in Southern Placer County was shared, rather than owned, by the Maidu or Nisenan Indians. They enjoyed the bounty of the fertile valley in and around what would become Roseville. By 1849, a small village was forming east of Sacramento, with an estimated 150 people living in an area that was approximately one square mile in size. Ranchers and farmers had begun building wooden structures for their homes and businesses. Life in the early days was simple for the Native Americans and the early settlers as they went about their daily lives, caring for the land and their families.

Some of the first settlers to come to the area were the families of Tobias Grider of Kentucky, Zachariah Astill of England, Thomas Dudley of Massachusetts, Martin Schellhous of Ohio, and Josiah Gould of New York. These pioneer families, along with many others, helped what started as a village to become a thriving railroad town, which in time became the city of Roseville. In the early days, many more families came to seek their fortunes in gold, or to gain from the development of a prosperous railroad town.

O. D. Lambert was convinced that this location would soon attract investors hoping to open booming businesses beside the railroad. On August 12, 1864, he committed his intricately detailed "Plan of the Town of Roseville at the Junction of the Central Pacific and California Central Rail Road" to paper, and filed it with the Placer County Recorder's Office. He believed that before investors could build a thriving town, an organized plan to engineer streets for housing and businesses would be a necessary first step. The date of Lambert's filing is remembered as the birthday of Roseville. Soon Lambert's dream became a reality.

Theodore Judah had a bigger dream. He was certain that a practical route for a transcontinental railroad across the Sierra Nevada Mountains was possible. His life was devoted to the creation of this railroad system, despite its many obstacles. Another man, Charles Lincoln Wilson, wanted to establish a railroad from Marysville to Folsom. Survey work between those two towns began in the spring of 1857. The railroad came to the small community of Roseville in 1861 through the Grider Ranch. The town was in those days referred to by many as Griders. Due to the visionaries who believed that a transcontinental railroad could become a reality, the community of Griders grew rapidly and became known as Junction. In the late 1800s, with the connection of the California Central Railroad and the Central Pacific Railroad, trains could travel east and west, and even change direction at the "Y," which was the junction. The town of Roseville was making a name for itself as a major player in the railroad industry.

Most likely, the first building in town was the freight depot for the trains, built alongside the tracks by Cyrus Taylor. In the Placer County records of 1882, Taylor is documented as the first official resident of the town. Taylor served as the freight agent of the Roseville junction from the first passenger train run on April 6, 1864, until shortly before his death in 1880.

By 1900, Roseville had grown from a sleepy ranching village to a railroad community bustling with activity and growth. The Southern Pacific Railroad Company announced the decision to

move its headquarters in 1906 from Rocklin to Roseville. This came to be referred to locally as the Big Move. The town population exploded almost overnight with all of the workers, their families, and the businesses that moved along with the railroad. From 1905 until 1910, the population catapulted from 250 to over 2,600.

Before artificial refrigeration, shipping perishables by rail was impossible without ice. Sizable ice ponds were created near the Donner Summit, and large blocks of ice were harvested there for the railroad. Once California began shipping produce by rail, the demand for ice was greater than the supply. By the early 1900s, artificial ice production began in California with the Pacific Fruit Express (PFE), which was owned by the Southern Pacific and Union Pacific railroads. The PFE ice plant in Roseville was built in 1907, and soon became the largest ice-manufacturing plant in the world and operated until the advent of self-refrigerated cars in the 1970s.

Roseville is a child of the railroad. The symbols associated with Roseville are its roundhouses, the ice plant, the railroad, and the rose. It is and will continue to be a "railroad town." Roseville's marshalling yards are reported to be the largest rail yards west of the Mississippi. The railroad companies have taken on many different names, and merged their companies over the years, and Roseville has kept up with the changes. Today the Union Pacific railroad, formerly known as Southern Pacific, and previously called Central Pacific, travels the rails through Roseville 24 hours each day. Most of the town's residents are accustomed to and enjoy the sounds of the railroad that lull them to sleep each night.

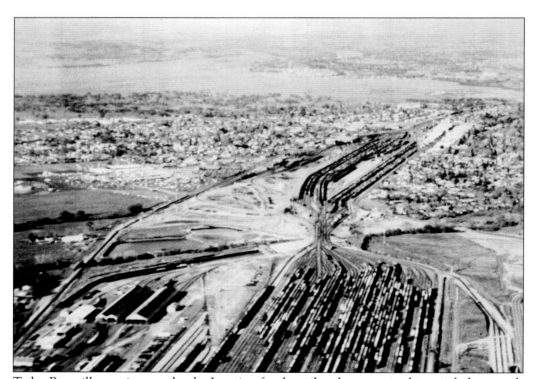

Today Roseville continues to be the Junction for the railroad, as seen in this aerial photograph of the switch yard. Roseville is known as one of the major railyards in Union Pacific Railroad's vast empire. The trains hitch and unhitch their engines in the switch yard to take their valuable cargoes to their destinations on tracks that run in many directions. Nonetheless, the old children's verse remains true: "North, south, east or west, Roseville is best."

One

THE RAILROAD

THE JUNCTION THAT BECAME A TOWN

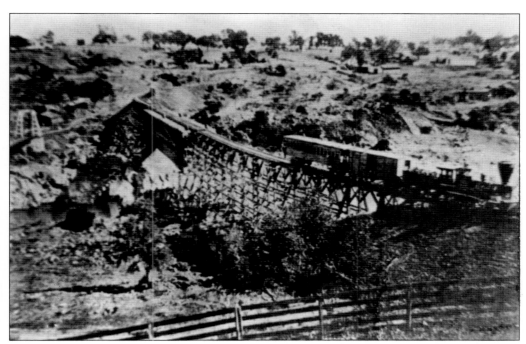

One of five locomotives owned by the California Central Railroad (CCRR) is pictured headed towards Lincoln, by way of Roseville, from Folsom. This extension of the CCRR started railroad operations in Roseville on October 13, 1861. Once the Central Pacific line met at the Junction (Roseville) in 1864, the Folsom portion of the California Central line was no longer useful. Service from Folsom to Roseville was discontinued in 1868.

The Folsom Road Bridge was built on the California Central Railroad trestle across Dry Creek after its closure in 1868. The rail bed for the CCRR through Roseville is now known as Folsom Road. A photographer took this familiar picture in 1870, looking toward Douglas Boulevard from Atlantic Street.

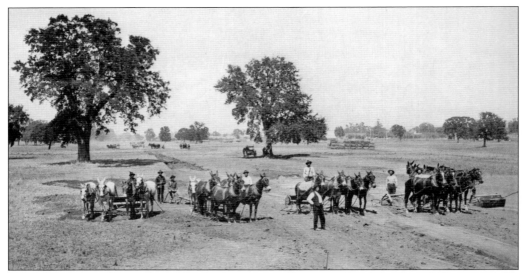

Farmers living in the area used their many teams of horses and equipment to help expand the railroad tracks and build the new Southern Pacific rail yards in Roseville during the early 1900s. Some residents had blacksmith shops and would fabricate tools and parts when needed. Their dedicated labor in grading the rail beds resulted in a quality stretch of tracks that became part of the nation's first transcontinental railroad line.

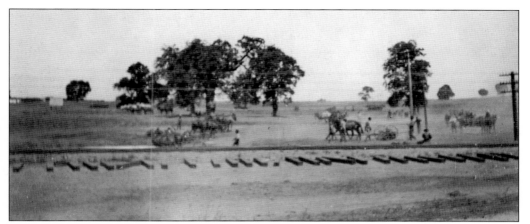

Workers are shown laying the ties and rails for the Southern Pacific Railroad (SPRR) expansion from Sacramento to Roseville in 1906. Many Greek, Italian, and Mexican immigrants were originally drawn to Roseville by the many job opportunities with the railroad. A booming railroad town emerged from the sleepy little village as the railroad kept growing. Some newcomers stayed and turned to other business enterprises when the railroad reduced its labor force.

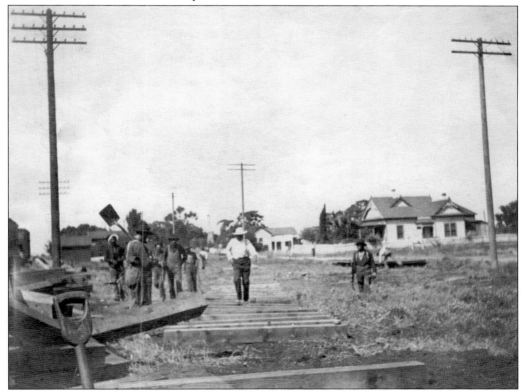

The Southern Pacific Railroad announced in 1906 the relocation of its headquarters to Roseville. The rail yards would be expanded, and Atlantic Street would be moved back 100 feet to accommodate all of the operations, as well as the reconstruction of the former Rocklin roundhouse. A large number of workers from Rocklin, local residents, and immigrants were employed to accomplish the enormous task of the "Big Move."

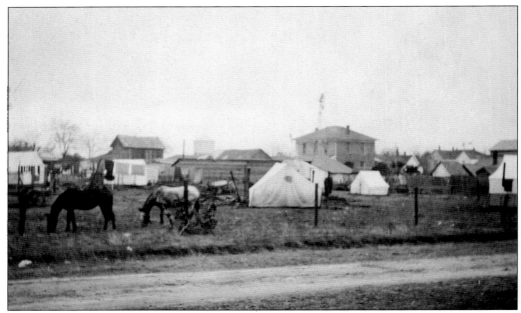

The railroad workers who came to help the SPRR move its headquarters from Rocklin to Roseville needed housing. Without enough housing in the small town to accommodate the large number of families who came to expand the rail yards and work in the newly built facilities, a temporary tent city was erected near the work site.

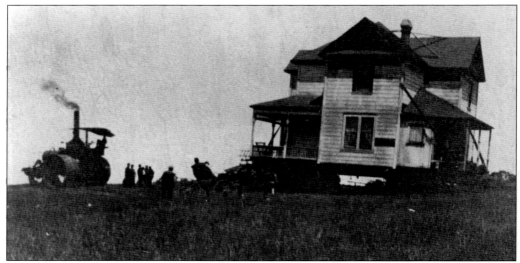

Some families moving from Rocklin to Roseville during the "Big Move" actually relocated their homes. The house was lifted up, logs or wheels were placed underneath the building, and it was pulled by a steam tractor or a team of horses. These were the world's first recreational vehicles: it took many days to travel the distance, so each night the family slept in their own beds, and ate meals prepared in their own kitchen.

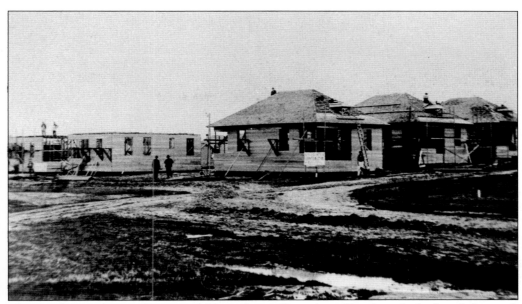

The population of Roseville increased from the small number of families who had settled to work the land to a bustling hub for the junction of the railroads. The population catapulted to over 2,600 by 1910. Some local businessmen took advantage of this growth by building single family houses, referred to as bungalows. Pictured above is one of these rental housing developments built by James Astill in 1906.

The Southern Pacific Clubhouse was built in 1908 for railroad workers lacking a home in town. Pictured in 1916, the sign above the door reads Southern Pacific Company Railway Club. Soon after the Seawell Underpass for Washington Boulevard was completed in 1949, the clubhouse was torn down. The site of the clubhouse remained empty until 1994, when the intermodal depot was built as a train and bus station.

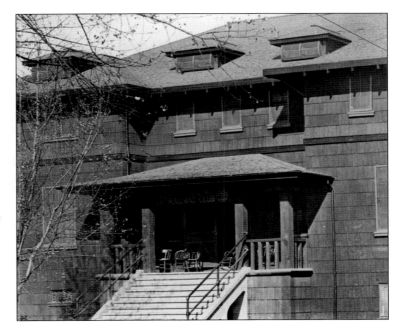

To mourn the Big Move of railroad facilities to Roseville, a funeral notice was posted all around the local communities. The removal of the roundhouse and all of the machinery was completed on April 25, 1908. Rocklin grieved the loss of not only the railroad but also the many related families and businesses. "We had the railroad, but lost it to Roseville," can still be heard in Rocklin.

𝔉𝔲𝔫𝔢𝔯𝔞𝔩 𝔑𝔬𝔱𝔦𝔠𝔢

DIED--At Rocklin, April 18, 1908,

The Rocklin Round House

A Native of California.
Aged 42 Years.

. . . FUNERAL . . .

Funeral services will be held at Porter's Hall,

Saturday Evening, April 18, 1908, at 8. P. M.

PALLBEARERS—J. Curran, J. B. Garity, J. Collins, Ed Folger.

HONORARY PALLBEARERS—L. W. WcCarl, J. E. Arnel,
A. Burke, T. Ronan.

Friends and acquaintances are respectfully invited to attend the funeral, where refreshments will be served.

Drays and Wheelbarrows will be ordered at 12 o'clock, Midnight.

Interment--Roseville.

N. B.—The Machinists will not be responsible for the Boilermakers' actions.

Moving the Southern Pacific headquarters from Rocklin to Roseville required expanding the rail yards to accommodate the buildings and additional tracks. It took two years to complete the facilities transfer to Roseville. Roundhouse No. 1 was rebuilt from the dismantled Rocklin roundhouse to store and repair the smaller switch and yard steam engines. The roundhouse had a turntable and 32 stalls that were each 85 feet deep.

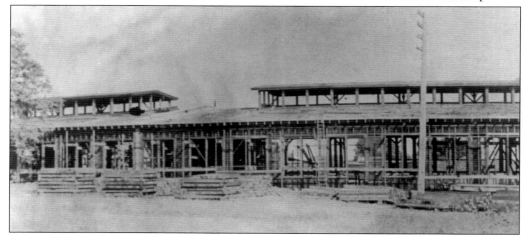

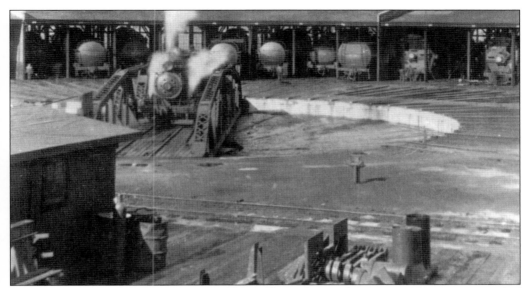

Roundhouse No. 1 had a working turntable, and housed steam locomotives that were in need of service. The smaller steam locomotives were placed on the 85-foot-long turntable to face them into the proper stall of the "Barn" or "House" for storage and repairs. Pictured here in 1920 is a steam engine all fired up and ready for the turntable to return the repaired engine back to the tracks.

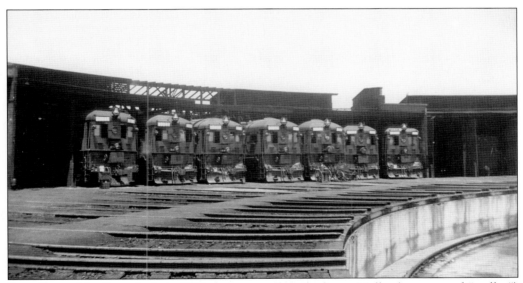

Roundhouse No. 2 was built in 1910 to accommodate the larger Mallet (pronounced "malley") steam locomotives. The roundhouse pictured here in 1938 housed 32 engines, but the turntable and longer stalls were 120 feet in length. Roseville had two of the largest roundhouses in California. The more efficient diesel-powered engines phased out the much-loved steam engines in the 1950s. Both roundhouses were eventually removed to make room for diesel repair shops.

Cassie Tomer Hill, widow of George W. Hill, assumed the positions held by her husband upon his death. She served as telegraph operator, railroad agent, and Wells Fargo agent in the Roseville Depot from 1885 to 1907. Cassie and her five children maintained living quarters in one end of the depot; the railroad depot occupied the center of the building, and a saloon was housed in the other end.

Cassie Hill continued to work as the only woman agent along the Central Pacific Railway until the old, outdated, and deteriorating depot building was torn down. Cassie had loved the place for so long that upon its closing and her retirement, she wrote a poem. The *Roseville Register* published "The Old Depot" in March 1907. Cassie Hill lived to the age of 101 years!

THE OLD DEPOT

The old home is not what it used to be
The thoughts lurk near me still,
'Tis but the fleeting past I see
Where all is calm and still.

Thirty years have passed since first
I trod its threshold dear to me,
And now 'tis but a dream of yore
The old house I cannot see.

My children, from their infancy,
No other home they knew;
And now how sad for them to see
The old go for the new.

Henry too has left me
Pastures new to find
But ponders o'er the past to see
And dreams of things unkind.

And wonders why this change is made
The new town "is to be,"
But claims 'tis nothing more than this-
The cruel Espee.

My greatest comfort now
Is little Hillie dear,
With eyes of thoughtful earnestness
And mind of gentle cheer.

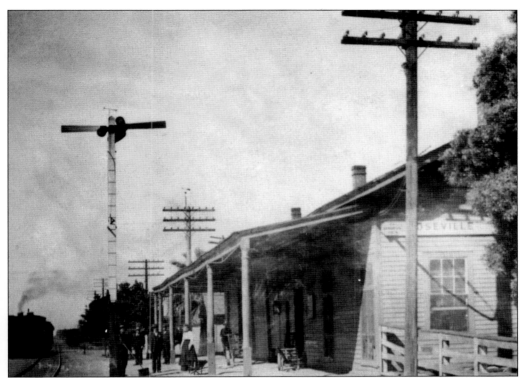

The first permanent train depot had served travelers from 1874 to 1907. The old depot was torn down in 1907, after a new depot had been built near the "Y" in the railroad tracks where the transcontinental lines meet. A portion of the old depot was taken to Atlantic Street, and was reconstructed to eventually become the Old Depot Saloon.

Roseville Depot Park, pictured in 1906 alongside the train depot, was more than just a travelers' rest stop, it was the cultural center for town events, gatherings, and performances. On the left is the bandstand gazebo where events and performances were staged. A cart holding 100 feet of hose weighing more than 600 pounds was stored underneath the gazebo for fighting fires on the north side of town.

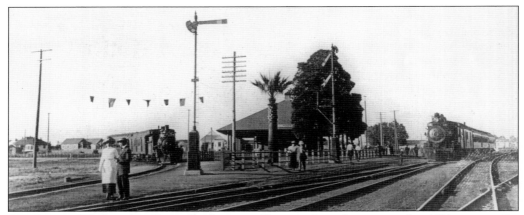

The famous "Y" that gave Roseville the name "Junction" can be seen in this 1911 picture. On each side of the train depot are trains arriving from different directions. The late Alan Aske, a life-long railroad worker, identified the 521 Chico Motor (left), a two-car passenger train arriving from the north, and the 109 Colfax passenger train (right) arriving from the east.

TIME TABLE.

SACRAMENTO DIVISION.

SACRAMENTO TO TRUCKEE.

R. H. PRATT, *Division Superintendent.*

WEST FROM OMAHA.		SACRAMENTO TIME.			EAST FROM SAN FRANCISCO.	
Daily Emigrant and freight.	Daily Express, 1st & 2d Cl's	Distance from Omaha.	STATIONS.	Elevation	Daily Express, 1st & 2d Cl's	Daily Emigrant and freight.
5 00 a m	11.30 p m	...1655..	Lv........‡TRUCKEE........Ar	...5845.	11.00 p m	9 00 p m
5.25	12.00	...1662..Strong's Canyon6780..	10.32	8.15
6.45	12.35 a m	...1671..‡Summit7017..	10.00	7.25
7.18	12.57	...1675..Cascade6519..	9 40	6.50
7.40	1.10	...1679..Tamarack6191..	9 27	6.25
8.00	1.28	...1683...‡Cisco...........	...5939..	9.15	6.05
8.50	1.55	...1691..‡Emigrant Gap.....	...5229..	8 40	5 10
9.25	2.15	...1697..‡Blue Canyon.....	...4677..	8.15	4.30
10.15	2.42	...1702..Sandy Run.....	...4154..	7.35	3.40
10.55	3 00	...1706..†Alta3612..	7.10	3.00
11.10	3.07	...1708..Dutch Flat.....	...3403..	6.55	2.30
11.30	3.15	...1710..†Gold Run.....	...3206..	6.45	2.15
12.15 p m	3 35	...1617..C. H. Mills.......	...2691..	6.20	1.25
12.45	3.52	...1721..‡Colfax...........	...2421..	6.00 •	12.45 p m
1.15	4.08	...1725..N. E. Mills..........	...2280..	5.16	11.50
1.35	4.20	...1728..Applegate.........	...2000..	5.02	11.20
1.55	4.31	...1732..Clipper Gap.......	...1759..	4.50	11.00
2.35	4.55	...1739..†Auburn.........	...1362..	4.22	10.15
3.05	5.12	...1744..†New Castle.....	...969..	4.02	9.30
3.40	5.32	...1750..Pino...........	...403..	3 40	8.45
4.00	5.45	...1752..‡Rocklin.......	...248..	3.25	7.45
4.10	6.02	...1757..†Junction.........	...163..	2.57	7.22
5.00	6.12	...1760..Antelope.........	...154..	2.48	7 05
5.32	6.30	...1767..Arcade...........	...55..	2.32	6.30
5.53	6.42				2.09	6.05

Trains traveled the rails from Truckee to Sacramento daily, carrying passengers and freight to the Junction. This timetable used by both engineers and passengers notes each stop's distance from Omaha, its elevation, and the amenities available there. Although the bustling town was already officially named Roseville, the train engineers continued to call the stop in southern Placer County "Junction."

By 1972, the railroad saw the demise of passenger trains stopping in Roseville. Passengers from Roseville would now go to Sacramento to catch a train. The train depot, now that it was no longer useful to the railroad, was to be dismantled and put to rest. A funeral with full honors was held on February 13, 1972. The depot would be interred in Rocklin (railroad humor), where the railroad facilities had originated.

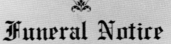

Funeral Notice

DIED - At Roseville, February 13, 1972
The Southern Pacific Passenger Depot
A Native of California
Aged 62 years

...FUNERAL...

Funeral services will be held at the Depot Site

SUNDAY AFTERNOON, FEBRUARY 13, 1972
at 12 NOON

FUNERAL DIRECTOR - CHUCK "CHOO-CHOO" LUCAS

PALLBEARERS - George Conroy - Tom Bautista - Pete Gieck - Gene Gieck

HONORARY BEARERS - Howard Scribner, Ivan Quincey, Lee Roullier

Steve Kerwin, "Swede" Svendsen, Bill Adrian, Tom Lucas

Eric Nau, Roger Barkhurst

The Reverend Hap Cribb - Officiating

Friends and acquaintances are respectfully invited to attend
the funeral where refreshments will be served.

Interment - Rocklin

After 22 years, the city council convinced the railroad that there were enough potential riders to warrant a new station in Roseville. The intermodal facility serving as both an Amtrak and Greyhound station opened March 5, 1994, with 1,200 people on hand for the celebration. The first trip sold 900 passenger tickets to board the San Francisco–bound train. The distances posted on the sign are 106.6 miles to San Francisco, and 2,162 miles to Chicago.

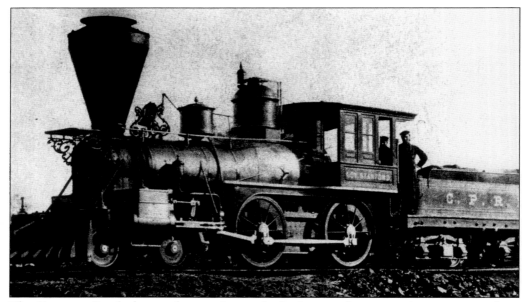

The *Governor Stanford* steam locomotive made the inaugural run, carrying passengers from Sacramento to Roseville, on April 6, 1864. The Central Pacific Railroad had made the pioneer run on what would become the nation's first transcontinental rail line. Roseville would soon develop into the largest rail yard west of the Mississippi.

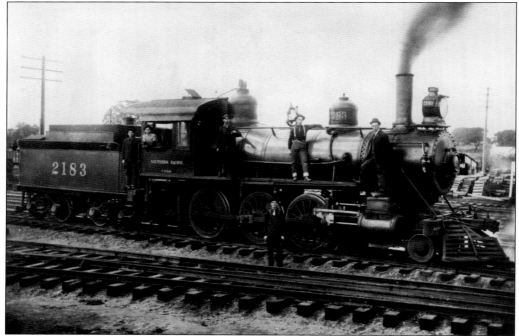

Steam locomotive 2183 is fired up and ready to go. Pausing before departing Roseville in 1907 are, from left to right, ? Haley (in the gangway), Jerome Starkey (the engineer in the cab), Al Layton (the fireman by the pump), ? Malone (on the running board), and Pete Crow (the engineer foreman on the steam chest). Standing on the ground is the switchman, Albert Aske.

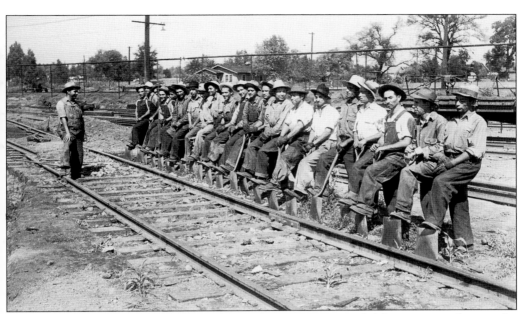

During World War II, the United States signed an agreement with Mexico to supplement the work force on the railroads. Starting on April 29, 1943, more than 200 Mexican nationals, called *braceros*, would work in the United States as paid employees of the railroad. It was a win-win situation: many of the men, upon returning to Mexico, had earned enough money to start a business or buy a farm.

In World War II, while husbands were away fighting for freedom, some wives were filling the vacancies in the rail yards. Pictured in front of steam engine 1402 are some of the "Rosie the Riveters" working to keep the railroad running. The amazing collection of women, high school students, Native Americans, and Mexican nationals who filled the gaps in the 24-hour labor force during the war will not be forgotten.

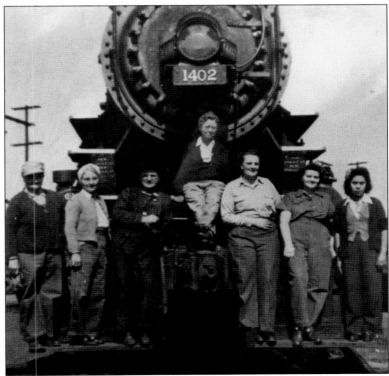

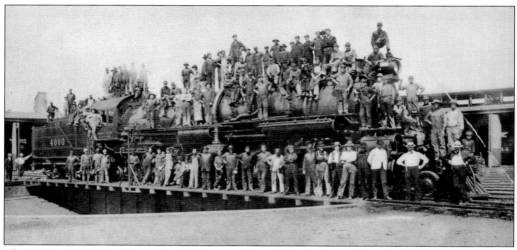

The 1909 arrival of mallet engine 4000 was celebrated by the Roseville railroad crew and engineers with a photograph. The stronger mallet steam engines were used on mountain runs over the Sierra Nevadas. The flaw in the early mallets was that the cab in the engine was placed too far back; the smoke in the tunnels and snow sheds would enter the cab, making the crew ill.

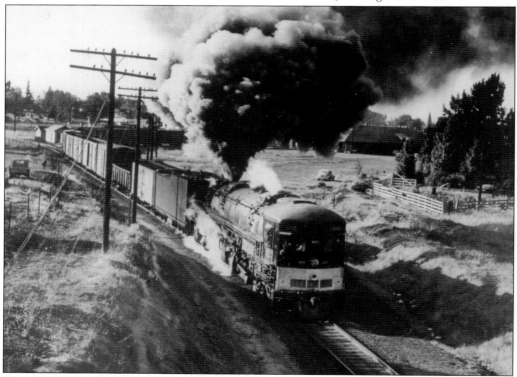

One of the last steam locomotives, a giant articulated mallet, is seen from the Sierra Vista Bridge as it leaves Roseville. This model of the mallets with the cab-forward engine was unique to California, constructed to navigate the Sierra Nevada Mountains. The relocated cab resolved the problem of smoke entering the crew cab. Not long after this picture was taken, the powerful diesel locomotives took over, and the mallets were retired.

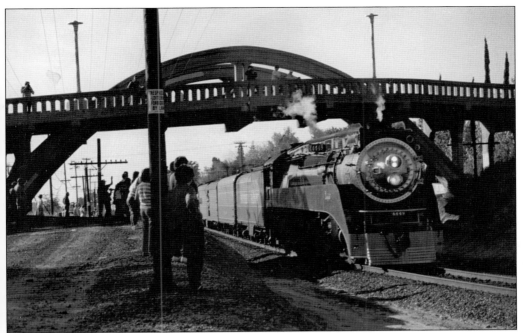

This photograph captured an early steam locomotive pulling train cars through Roseville in 1991 on its way home. The train had probably been brought out of retirement for a rail fair event in Sacramento. It is passing under the Sierra Vista Bridge, traveling north out of town. Most town folk call this landmark bridge, built in 1929 near the Carnegie Museum, either the "rainbow bridge" or the "crooked bridge."

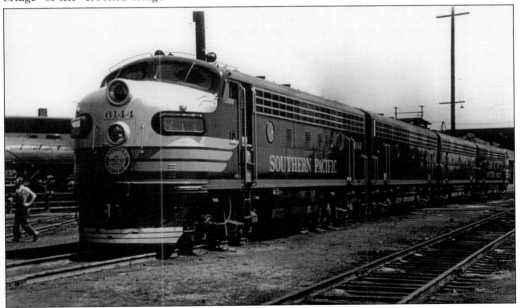

One of the first diesel-powered locomotives to operate in the local railroad yards was the 6144 engine, which came to Roseville on June 27, 1949. The arrival of the diesel engines rang the bell for the end of the steam engines' reign.

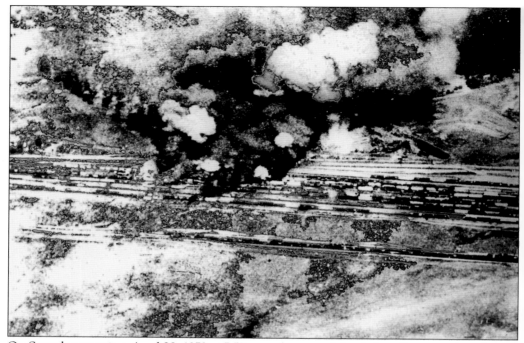

On Saturday morning, April 28, 1973 at 7:52 a.m., the ground shook for miles around, and many people thought the world was coming to an end. This aerial photograph shows the rail yard explosion near Antelope. Twenty-one boxcars loaded with ammunition, intended for Vietnam, started to burn and explode. All of Antelope and most of Roseville were evacuated. There was massive damage to Antelope, the railroad tracks, and many train cars.

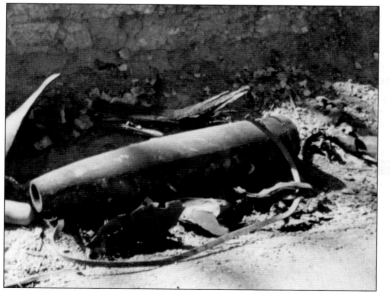

In Antelope, many homes and businesses were damaged or destroyed, but no lives were lost. "It was a miracle," the local paper proclaimed, "that no one was seriously injured or killed." Pieces of metal and shrapnel were thrown all over the surrounding area. Pictured is one of the many unexploded bombs. Had the blast happened closer to Roseville, the damage in town and the casualties would have been tremendous.

Two

PACIFIC FRUIT EXPRESS
THE WORLD'S LARGEST
ICE-MANUFACTURING PLANT

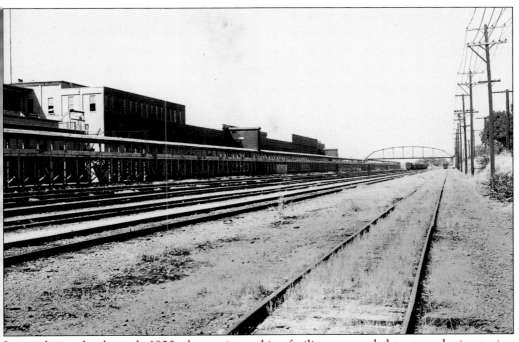

It was obvious by the early 1900s that an ice making facility was needed to serve the increasing transportation of perishables by rail. In 1907, the Pacific Fruit Express (PFE) started building an ice plant in Roseville. The Roseville PFE Ice Plant had the distinction of being the largest ice-manufacturing facility in the world. The pedestrian bridge, visible down the tracks, kept plant workers safely above the moving trains.

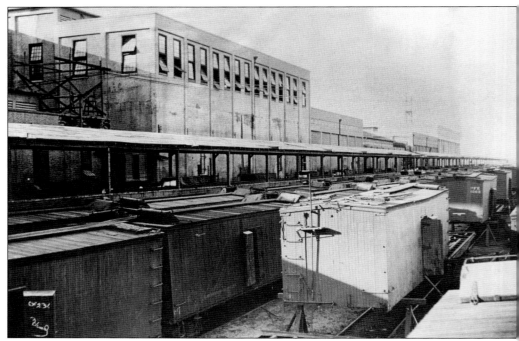

The PFE ice plant became a reality when the building was completed in 1908. The two- and three-story buildings had a storage capacity of 11,000 tons of ice. By 1929, PFE could service up to 256 cars at one time. Blocks of ice were constantly in demand as trains arrived from all along the Pacific Coast for re-icing before traveling over the Sierra Nevada mountains.

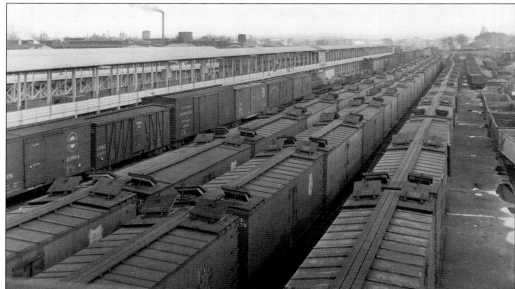

By 1924 the increasing demand for ice led PFE to expand the plant. After the company spent more than $750,000, the plant could hold 30,000 tons of ice. As the railroads became more widespread, the need for ice blocks increased greatly. Here the tracks are filled with refrigerated cars, or "reefers," waiting for the re-icing of their open top compartments, called bunkers.

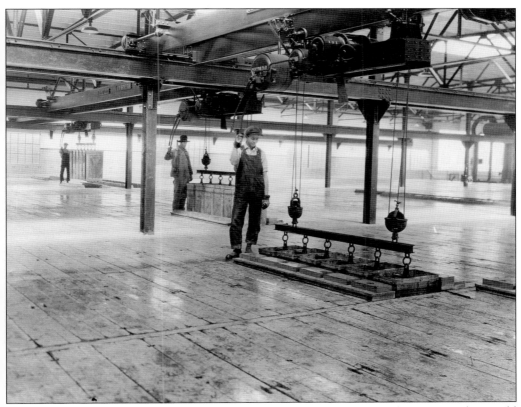

Underneath the expansive floor of the tank room were a large number of containers that could each freeze six 300-pound blocks of ice. A crane was required to lift out the molds of frozen blocks, which were sent first for processing, and then to one of the many storage rooms. Close to 400 tons of ice were processed daily in the 24-hour plant.

Containers were lifted by machine and turned on their sides to allow the ice cakes or blocks to slide out. This was referred to as "pulling the keg." From this point on, the ice would be manually handled with the use of huge tongs, picks, and iron bars. The next stop was the storage room, where thousands of blocks would be stacked until needed up on the icing platforms.

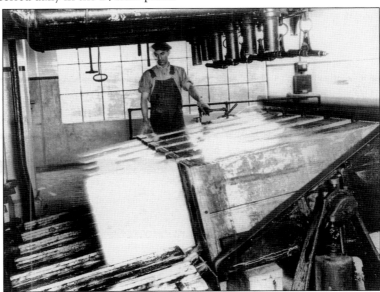

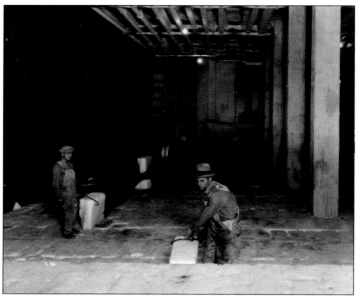

Ice ponds near today's Truckee initially met the railroad's ice needs for shipping produce to the East Coast. Demand for large ice blocks west of Donner Summit greatly increased in 1869, when California started to ship fresh fruits. Storage rooms would at times be stacked to the ceiling with ice blocks, 16 or more feet high. Large tongs were needed to maneuver the 300-pound cakes.

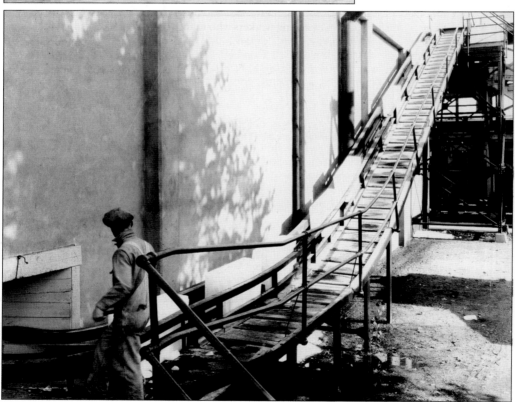

The ice cakes were sent by conveyor belt up to the icing deck. On a busy day, workers would move up to 2,700 tons of ice. Once above the mechanical refrigerated cars, known as "reefers," workers would re-ice the bunkers of each car to keep the perishable contents cold. A full 2.5 million tons of ice were processed in the post-war year of 1946, giving Roseville the nickname "Ice Capital."

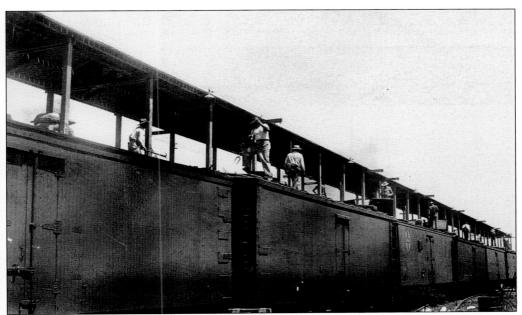

The reefers were re-iced from above by strong workers who maneuvered the 300-pound blocks from the icing deck into the compartments. A pick man would hook a block of ice and slide it across a plank. The barman would then break the ice up before pushing it into the bunker at each end of the car. Handling ice was back-breaking work. Note the sign, "Stop: Men At Work."

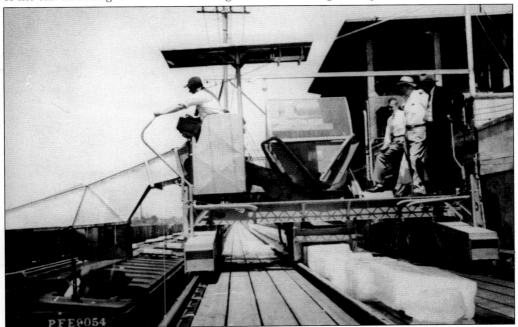

Mechanized ice-loaders were installed up on the icing decks in the 1950s. This man-operated machine ran down the length of the icing deck on its own set of tracks. It sped up the icing process, handling 5 tons of ice per minute. The teams of ice handlers, who for 40 years had manually re-iced a reefer in as little as two minutes, had been replaced by machines.

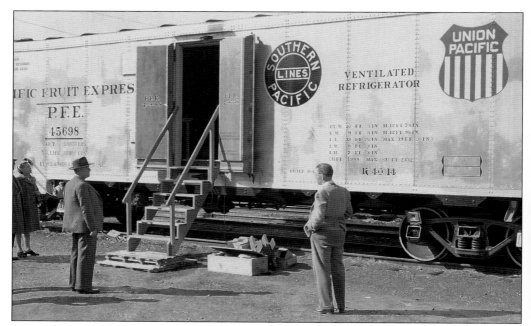

Pictured is a ventilated mechanical refrigerator boxcar. After cooling with ice, cargo would be loaded through the open doors. Roseville PFE had an inventory of 36,000 mechanical reefers that were in constant use. The first cars were constructed of wood, and with the advances in metal reefers came better refrigeration. The arrival of the first self-refrigerated boxcar in 1964 was the beginning of the end for the Ice Plant.

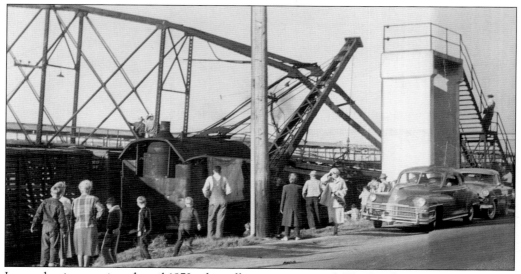

Ice production continued until 1973, when all operations ceased. The Southern Pacific and Union Pacific Railroads, co-owners of the ice plant, split their holdings, and removed all the structures in 1974, except for the bridge. It was relocated in 1987 for pedestrians to cross Dry Creek over to Veterans' Memorial Hall in Royer Park. The PFE ice plant made its mark in history, and now is just a fond memory.

Three

CITY GOVERNMENT
MORE PEOPLE, MORE SOCIAL STRUCTURE

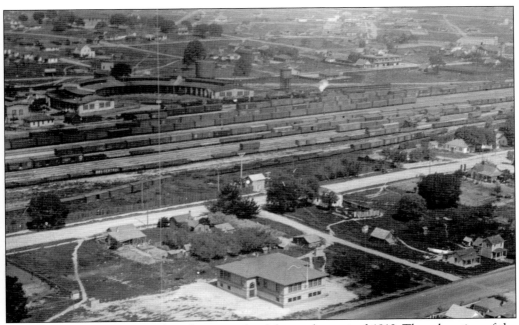

Roundhouse No. 1 is pictured on the west side of the tracks, around 1910. The relocation of the Rocklin roundhouse brought incredibly rapid growth to the sparsely populated town of Roseville. Before 1906, the population had leveled off to approximately 250 people, who considered each other friends and neighbors. It was suddenly apparent that social structure and governing rules were going to be needed to bring some order to the increased town population.

A group of concerned citizens formed the first level of city government by creating the Roseville Chamber of Commerce. On October 17, 1906, A. B. McRae chaired the first meeting. Thirty-two people signed up, and each new member paid a $1 membership fee. The chamber oversaw the improvements needed for the rapidly growing town. The real estate office in this c. 1908 photograph shows McRae seated in front of his desk.

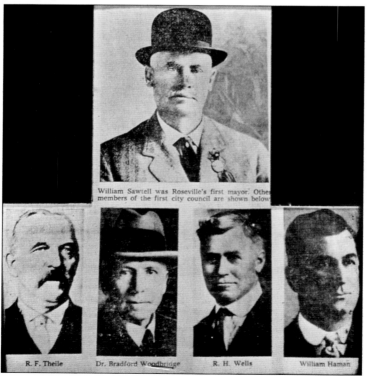

William Sawtell was Roseville's first mayor. Other members of the first city council are shown below.

R. F. Theile Dr. Bradford Woodbridge R. H. Wells William Haman

An election to incorporate the Town of Roseville and select the first city trustees was held on April 2, 1909. The voters elected William Sawtell (chairman), R. F. Theile, Dr. Bradford Woodbridge, R. H. Wells, and William Haman, who were pictured in a newspaper article remembering Roseville's humble beginnings.

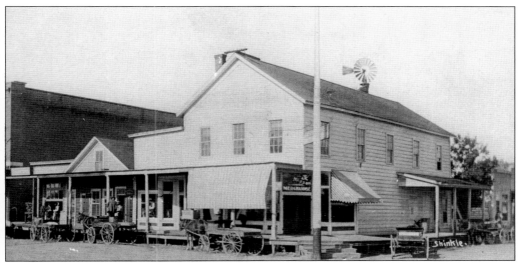

Finding a suitable meeting place for city hall was ever-challenging. The elected leaders first tried the bank building on Lincoln Street, but due to space problems, the meeting place was moved to McRae Hall. By August 1909, the hall over the Sawtelle Store (corner building), previously known as the J. D. Pratt Building, would serve as the first City Hall. Rent to use the building was $12 per month, which included janitorial services.

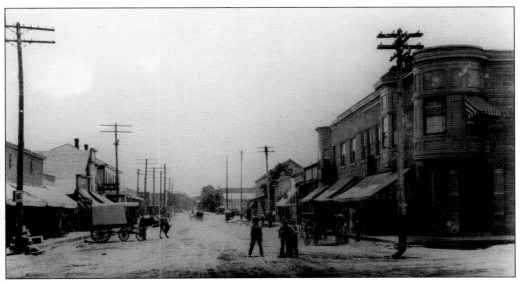

This photograph of Lincoln Street shows the Roseville Banking Company, built in 1907, on the right, at the corner of Lincoln and Church Streets. The city trustees held the first few city hall meetings in the bank building. This corner property, though it has gone through many changes over the years, and has a different building today, continues to be referred to as "Bank Corner."

The vacant Presbyterian church located on Vernon Street was purchased in 1911 to become the "permanent" building for City Hall. Opinions differed about where City Hall should be located. The voters decided that it would stay on Vernon Street, on the south side of town.

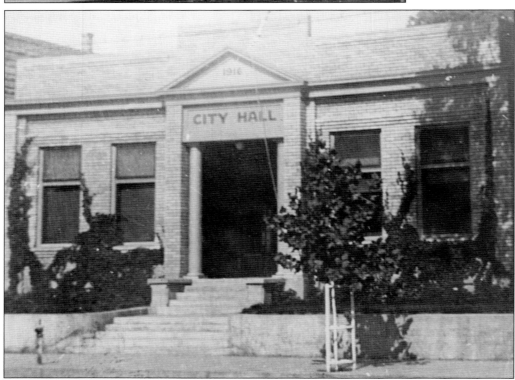

The church building, built in 1883, was moved and remodeled in 1916. A brick facade was added, and the steeple removed to give City Hall a more official appearance. There were only three employees working in city hall as of 1935. After the election in 1935, Roseville was re-classified as a charter city, which would restructure city government. The small town of Roseville was in for big changes.

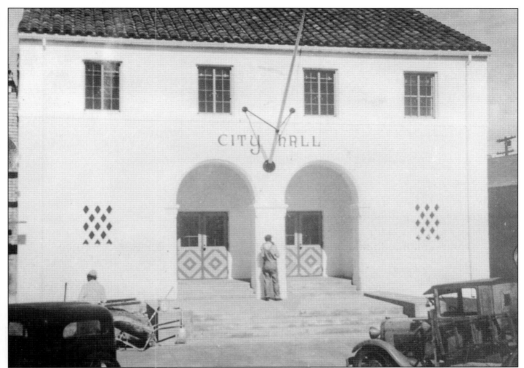

Pictured is the new two-storied City Hall as it appeared around 1936. The original building was turned sideways to be connected to the new structure for use as the City Annex. A portion of the old building is visible at left. The Police and Fire Department headquarters were located behind City Hall until the completion of the Public Safety Building on Oak Street in February 1973.

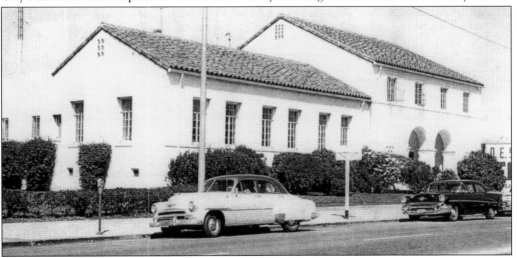

This photograph of Roseville City Hall in the 1960s shows the first, smaller City Hall (now an annex for filing records) attached to the second, larger City Hall on the right. This complex became the City Hall Annex, and housed the Planning and Public Works Department after City Hall moved across the street in 1987. The parking meters along Vernon Street have been removed, and can no longer be found anywhere in Roseville.

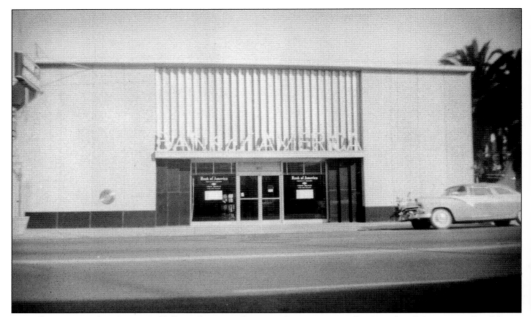

One last time the City Hall found a new home, this time in the Bank of America Building, pictured in the 1960s, directly across Vernon Street. This building was remodeled in 1987 with city council chambers and offices for the city manager as well as many other departments. The city was planning for the future as the population increase continued, which made Roseville one of the 10 fastest growing cities in Northern California.

Here is City Hall as seen in 1989. It has resided in the old Bank of America building at 311 Vernon Street since 1987. The new, modern, and beautiful Roseville Civic Center, finished in 2002, incorporated the original building. City services were not interrupted during construction since the employees were temporarily relocated to the corporation yards. Roseville's population by the year 2000 was estimated to be over 75,000.

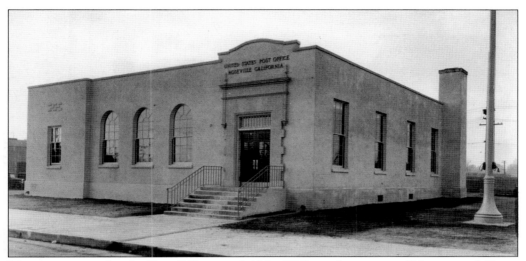

The cornerstone for the Post Office was laid in 1935, on the corner of Vernon and Grant Streets. This property, from the corner down to City Hall, was originally filled by Nevada Carson "N. C." Busby's Rooming House and Superior Garage. The transformation of the 300 block into the town's civic center had begun. The original post office, after renovations and additions in 1965, is still located at 330 Vernon Street.

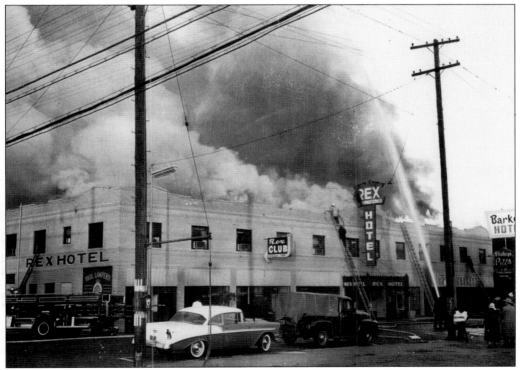

On October 1, 1961, Old Town lost a piece of history when the Rex Hotel on Lincoln Street became a three-alarm fire. The fire started in Shakey's Pizza and rapidly consumed the entire block of buildings, leaving only some outer walls standing. This was the second fire to destroy the building on the corner of Pacific and Lincoln Streets, where the first City Hall had been located.

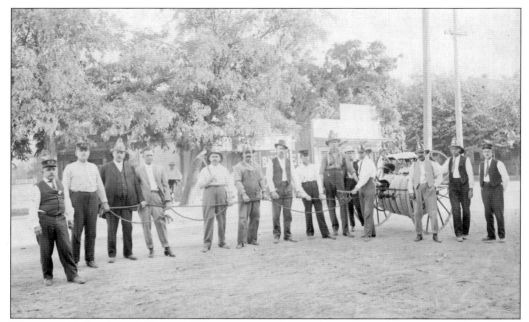

The Municipal Volunteer Fire Department was established in March 1910. Pictured here from left to right are chief Gottlieb Hanisch, Al Ridley, Murray Briggs "M. B." Johnson, R. J. Kruse, John Leles, George Cirby, James Beckwith, L. F. Pettit, George Jergens, Tony Mealia, John Hamilton, Louis Hoke, Jasper Jergens, and Lon Melton. Before fire engines, the hoses, weighing 600 pounds, would be pulled on carts. Twenty fire hydrants had been installed throughout town by 1908.

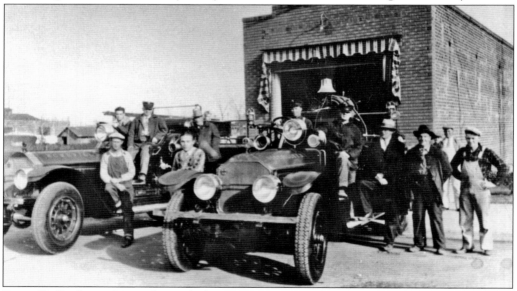

Roseville Firehouse No. 1, located where Main and Church Streets intersect at 400 Lincoln Street, was the first permanent fire station. It was built in 1921 and served the fire department continuously until its closure in 1947. The Roseville Fire Department volunteers of 1928 are, from left to right, C. Decator, Barney Pendergast, T. Decator, LeRoy Sharp, N. E. Rogers, C. White, A. Giekey, J. Sharp, and R. Bish.

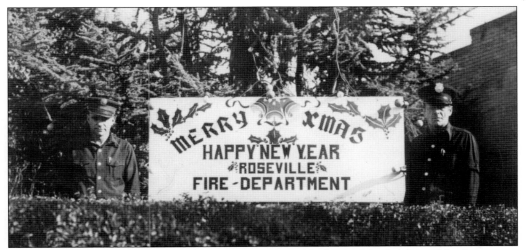

Firemen lighting and decorating the evergreen tree at Firehouse No. 1 (planted by firemen in 1926) started the Roseville tradition of lighting the "Roseville Christmas Tree" to officially start the holiday season. A new city tree is now lighted near the Civic Center. In 1933, the fire department was awarded first prize in the annual outdoor Christmas tree decorating contest. Here 1940 Christmas greetings are displayed between Delbert Bailey and Lester Astill.

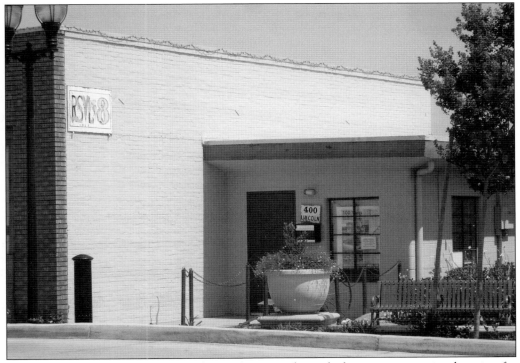

The historic brick building that no longer functioned as a firehouse, or a meeting location for the firemen, was re-commissioned as RSVL8, the city public access television station. Roseville Public Access station has since moved into its new location in the Martha Riley Community Library complex. Firehouse No. 1 is located at 400 Lincoln Street in Old Town, and is scheduled to become a museum honoring Roseville's heroic firemen.

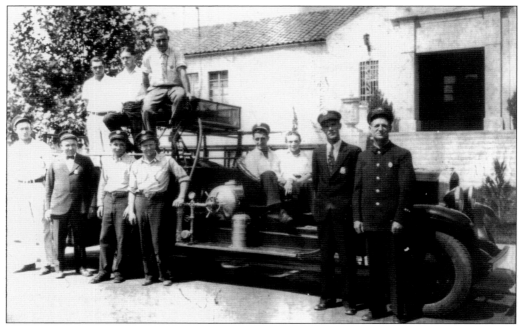

The Roseville Volunteer Fire Department of 1931 is shown posing with a fire truck on Vernon Street in front of City Hall. Pictured from left to right are (first row) Barney Pendergast, Chief Walter Hanisch, John Cavaini, N. E. "Puffy" Rogers, N. Kerhoulas, LeRoy Sharp, Avery Amick, and R. Preston; (sitting on top) Delbert Bailey, Francis Astill, and Thorburn Lewis.

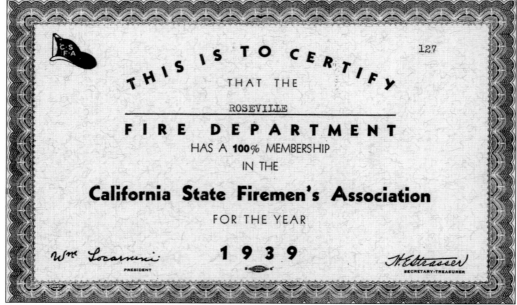

The California State Firemen's Association awarded the Roseville Fire Department this 100-percent membership certificate for the year 1939. This was quite an impressive accomplishment for a department whose firefighters were all volunteers. The fire department continued to rely heavily upon volunteers through the 1980s.

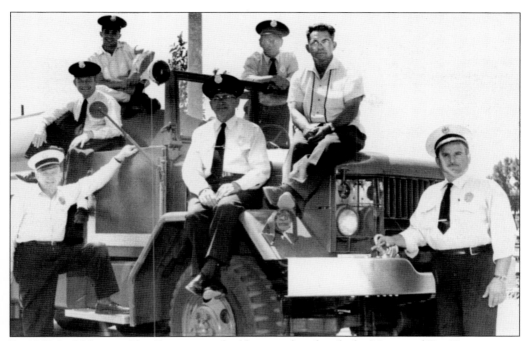

By 1947 the Volunteer Fire Department had been replaced with the Municipal Fire Department. These firemen pictured in the 1960s are, from left to right, N. E. "Puffy" Rogers, Vince Kelly, Charles "Buddy" LaPorte, Lynn Hubbard, Lester Astill, Delbert Bailey, and Fire Chief Peter Badovinic. Badovinic served as fire chief for 22 years, and insisted on rescue and resuscitation training for all his firefighters long before it became a required standard.

The Roseville Fire Department celebrated 100 years of excellent public service in 2007, as commemorated on this belt buckle. Roseville's firefighters continuously train to prepare them for many different types of emergencies and fires at the Roseville Fire Training Center, which the department shares with the Fire Technology program at Sierra College. In 2005, Roseville was certified by the Commission of Fire Accreditation International.

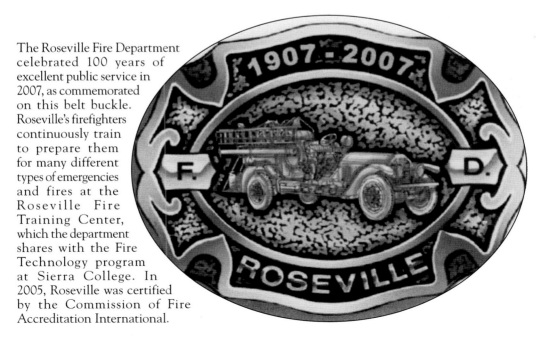

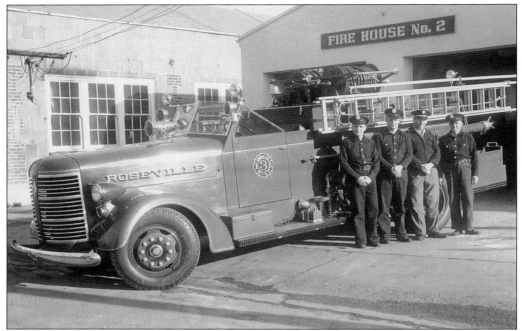

Fire House No. 2, pictured in the 1960s, was built behind City Hall during the 1936 remodeling of city facilities. A bigger building was again being planned to care for the rapidly increasing city population. The site previously occupied by Placer County Winery in 1906, and Roseville Ice and Beverage Company in 1922, was selected for the proposed Public Safety Building at the end of Grant Street on Oak Street.

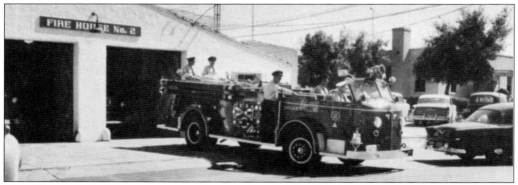

This photograph of fire engine number two leaving Firehouse No. 2 was taken in 1957. The building to the right is the post office building at the corner of Vernon and Grant Streets. The driveway exiting the fire station was on Atlantic Street next to the railroad tracks, with easy access to the other side of town via Oak Street and the Seawell Underpass.

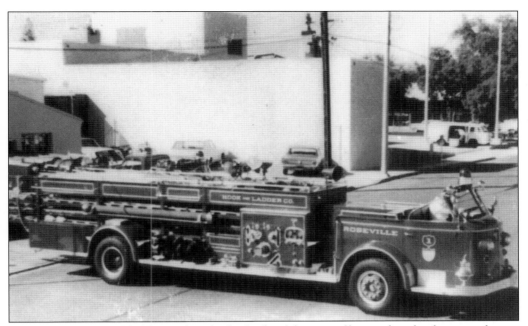

Behind this hook and ladder truck is the backside of the post office, and in the distance, the top of the Tower Theater. The population in Roseville had almost tripled over 30 years from 6,653 in 1940 to 18,221 in 1970. A larger facility for the Roseville Fire and Police Departments could no longer wait. The Public Safety Building at 401 Oak Street was completed in 1973.

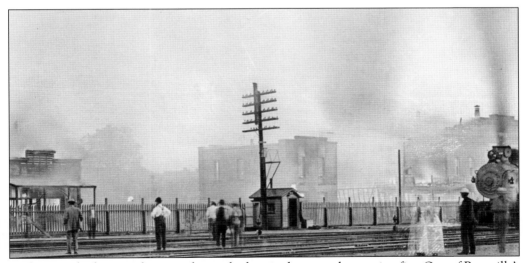

Unfortunately the main business district had more than one devastating fire. One of Roseville's more memorable fires occurred on August 24, 1911. It consumed all of the buildings on Pacific Street, leaving only the brick exterior of the Odd Fellows building, seen at far right across the tracks. The Odd Fellows building on Pacific Street, Roseville's first brick structure, built in 1878, remains standing today as a testament to her colorful past.

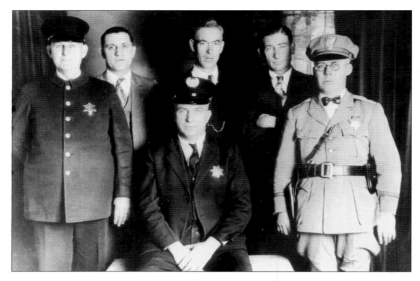

Russell Carter was the city's first police chief. He is shown seated here in 1931 with the rest of the newly formed Roseville Municipal Police Department. The others are, from left to right, Charles Trimble, Joe Zanolio, Pat Shelly, William Elam, and Bob Cirby.

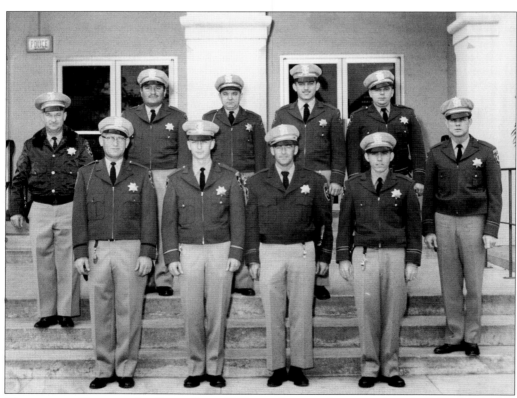

The reserve officers serving Roseville in 1962 pose here on the steps of city hall. Established in 1956, the RMPD originally recruited these "auxiliary" officers to supplement the overworked police department. The reserves, all volunteers, would not only attend training sessions, but would also purchase their own uniforms and firearms.

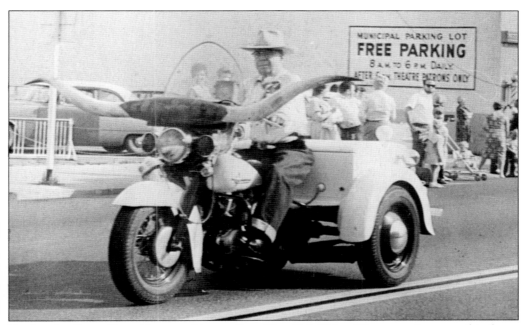

For decades, Roseville residents could see police officer Bob Cirby riding around town on his three-wheeled service motorcycle. This 1964 image shows Cirby taking part in the Roseville Centennial parade down Vernon Street. The longhorns were a tribute to the ranching community. In 1964, Roseville celebrated its first 100 years with a year full of activities.

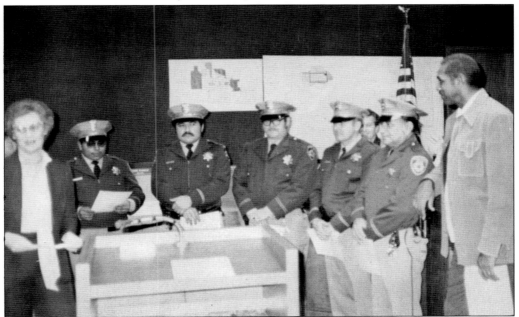

June Wanish was not only the first woman elected mayor of Roseville, but also the first woman elected to city council. She is shown here recognizing outstanding service by the Roseville Police Reserves in the 1970s. The Roseville Police Department was recognized in 2000 for Excellence in Community Policing by the International Association of Chiefs of Police.

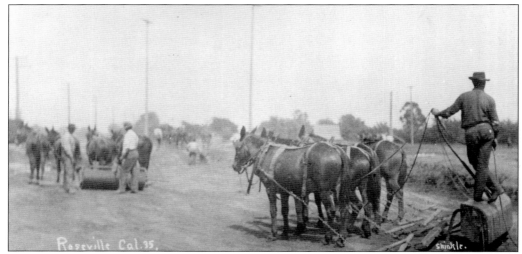

Construction of roads was dusty, dirty, and hard work for both men and horses. This photograph taken in the early 1900s shows the dedication of Roseville's volunteer citizens to improving travel to and through town. As the town's population increased with the arrival of the railroad headquarters, so did development and the need for more streets.

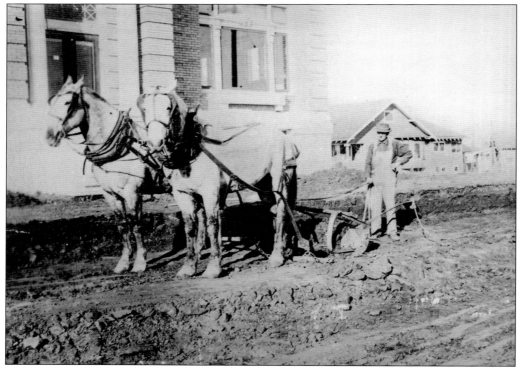

In 1907, William Keehner went to work for the City of Roseville, and was in charge of street maintenance as well as other duties. Keehner supplied his own team of horses in order to grade the streets around town. He is shown here in 1912, grading the road in front of the newly built Carnegie City Library at 557 Lincoln Street.

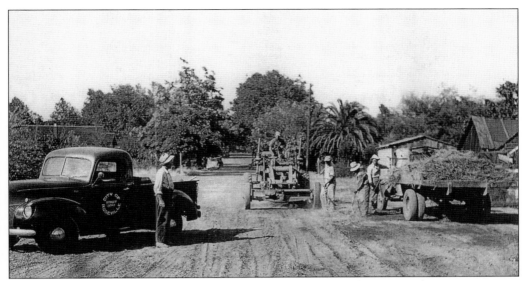

The City of Roseville eventually hired more workers to grade and maintain the many streets in Roseville. It was a constant job to keep the streets passable, since most were just dirt. In the winter, the rain and the resulting ruts made by tires created more than enough work to keep them busy. Pictured are some of the workers who kept Roseville's roads usable.

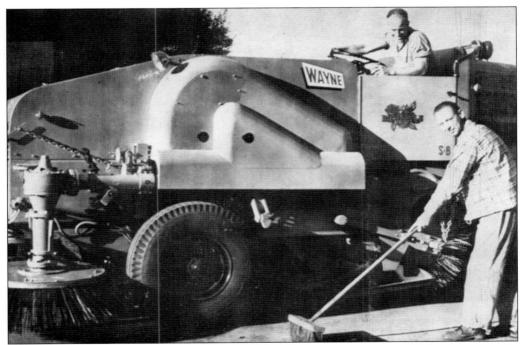

Roseville purchased a new engine-driven, man-operated street sweeper in 1956 to keep up with the town's growing population, which was nearing 9,000. In this photograph, Paul Free drives the new piece of equipment, while Carl Smith demonstrates the old-fashioned sweeping still needed for street work.

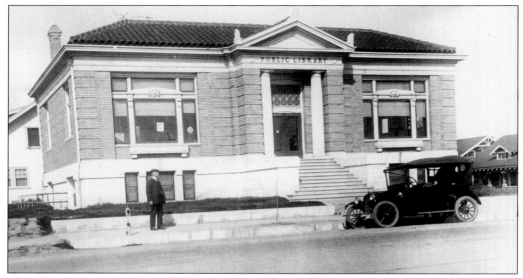

The Women's Improvement Club decided the city needed a library, and began a campaign to raise funds. With a $10,000 donation from Andrew Carnegie, donation of land and labor by A. B. McRae, and local funds raised, the Carnegie Library would become a reality. The city dedicated and opened the library in 1912. This would be the only city library, shown c.1920, until the Taylor Street branch was built in 1976.

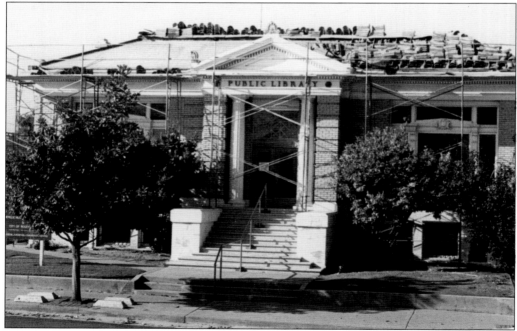

In 1983, the Roseville Historical Society was formed. Its motto, "To preserve and promote the history of Roseville," inspired a project to refurbish the old library. The City of Roseville and the society sponsored the restoration. On October 12, 1988, the Carnegie Library was dedicated and opened its doors once again, now as the Carnegie Museum. The inscription "Public Library" above the entrance has been changed to "Carnegie Museum."

Four

CHURCHES AND EDUCATION
UNITING THE COMMUNITY

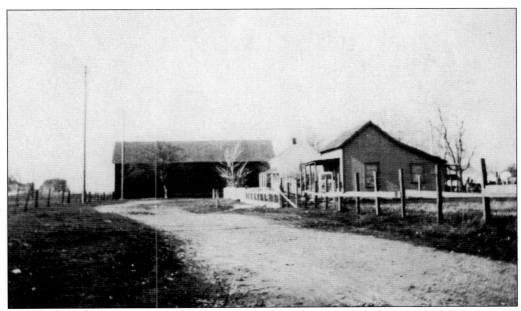

Before there were church buildings, people wanted to share their religious beliefs and gather for worship. When the traveling preacher came to town, worship services and other events were held in local barns, like the one pictured here. The first recorded wedding in Roseville was on October 6, 1869. The construction of Pioneer School in 1872, a one-room schoolhouse on Atlantic Street, was intended for religious and community gatherings as well as school classes.

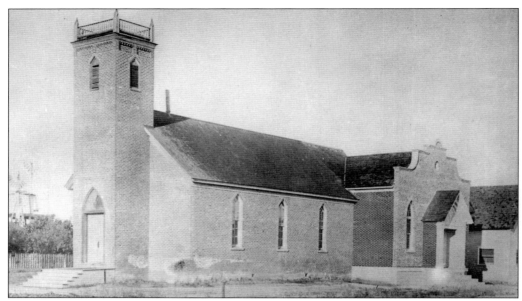

The Methodist Church was Roseville's first permanent church. The congregation gathered in members' homes until the building was completed in March 1883. Anna Judah, widow of Theodore Judah, donated land for the church site and everyone in town contributed to the building. The dedication for the church closed down the entire town, even the saloons. In 1907, additions for a parsonage and social hall were built on the back, as seen here.

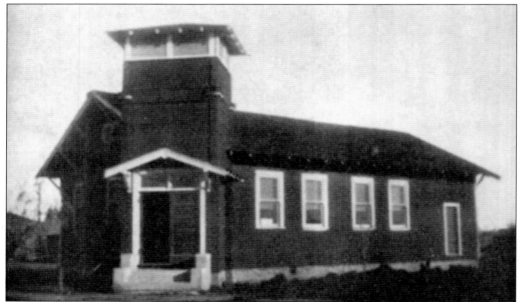

The "Mission Chapel" was built in 1914 as a second place of worship for the Methodists on the other side of the tracks. The church was built on land donated by Anna C. King from the King's Cherry Orchard family property. Commonly referred to as Cherry Glen Mission, the building on the corner of Bonita and Clinton Streets was sold to another church when it closed operations in 1944. It was later replaced with a housing development.

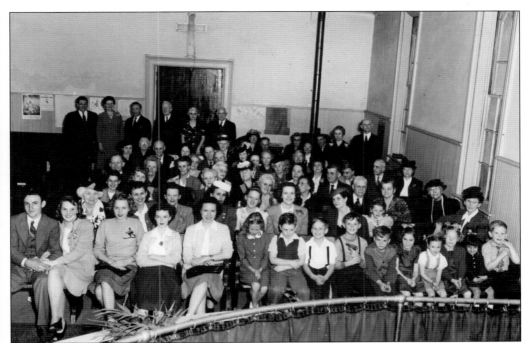

The members of the First Methodist Church of Roseville were photographed the day they celebrated the 64th anniversary of the church in 1947. Many people have held services and weddings over the years in the beautiful sanctuary with stained glass. The Boy Scouts have also used the church as their meeting place, and have held Eagle Scout and award ceremonies in the halls and sanctuary.

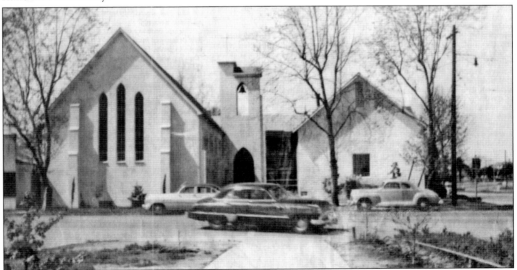

The First United Methodist Church at 109 Washington Boulevard was remodeled for safety and expansion in 1954, including a new sanctuary. Later construction removed the crumbling tower, and a new tower was erected along with a centrally placed entrance that gave the church a new look. The facilities are currently used seven days a week for church activities and service to the community, including the Gathering Inn program for the homeless.

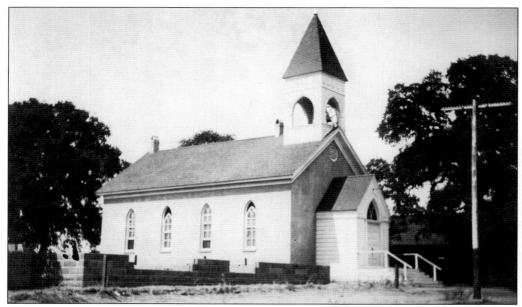

The First Presbyterian Church was completed in 1883, just a few months after the Methodist church. Originally called the United Brethren Church in 1850, its members met in a cabin prior to the completion of this building. All of the property on Vernon Street between Grant Street and the Presbyterian Church was purchased by Nevada Carson Busby. Pictured on the left is the foundation for Busby's Rooming House, under construction around 1907.

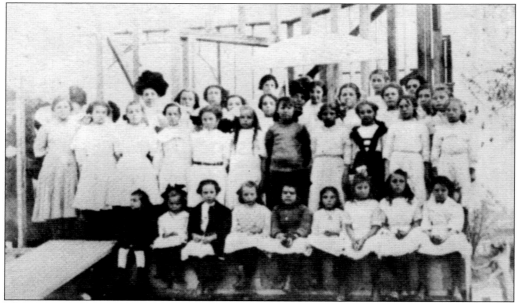

The cornerstone for the First Presbyterian Church at 100 Lincoln Street was set on November 25, 1911. The new building would be multi-leveled with a social hall, a kitchen, and Sunday school rooms, as well as a swimming pool in the basement. After the completion of the second building in 1912, the church vacated the Vernon Street facility, and the city trustees bought it to house Roseville City Hall.

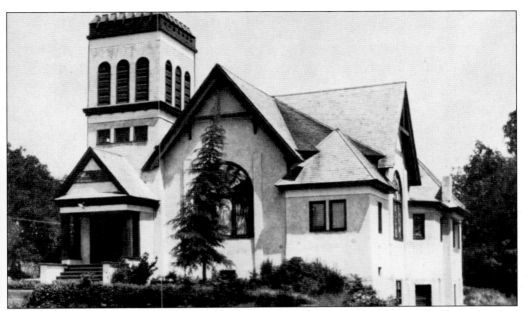

The First Presbyterian Church's second building on Lincoln Street was home to the denomination from 1912 to 1967. The operational church bell became inaccessible when years later a spire was added to the bell tower. It became a challenge to remove the bell years later. Successfully extracted, it can now be found and heard in the church on Sunrise Street. Salvation Army Community Corps now occupies the 100 Lincoln Street church building.

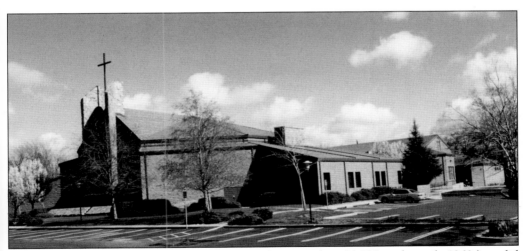

As Roseville's population continued to increase (to more than 14,000 in the early 1960s), so did the Presbyterian church's membership. Ground was broken in August 1967 at the corner of Sunrise and Coloma Streets for a larger multi-use facility. In the following decades the church continued to expand, building a new sanctuary and making major improvements that were completed in 1987. First Presbyterian Church continues to offer services at 515 Sunrise Avenue.

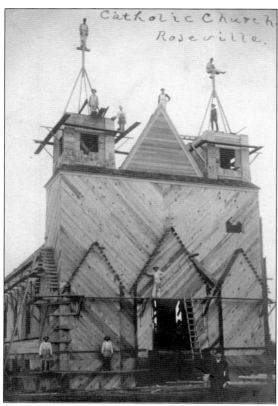

Saint Rose of Lima Catholic Church became an organized parish in 1894, and met in Branstetter Hall on Pacific Street. Its first permanent building (on Grant Street between Vernon and Oak Streets) is shown here in 1910, nearing completion. Saint Rose became the third religious organization in Roseville. An estimated 200 to 300 parishioners from Roseville and the surrounding area attended mass in the new parish.

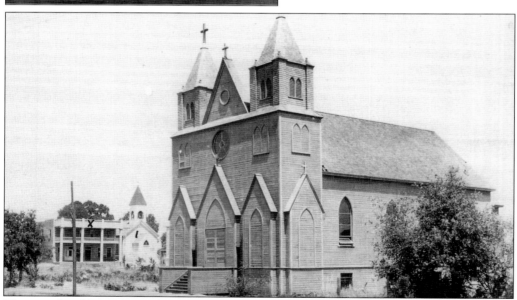

The completed Saint Rose of Lima Catholic Parish held a dedication ceremony on May 8, 1910. This view of the newly completed church from Oak Street shows the Busby Rooming House and the Presbyterian Church in the background. The first Sacrament of Confirmation was administered here on November 30, 1913, to 24 boys and 22 girls.

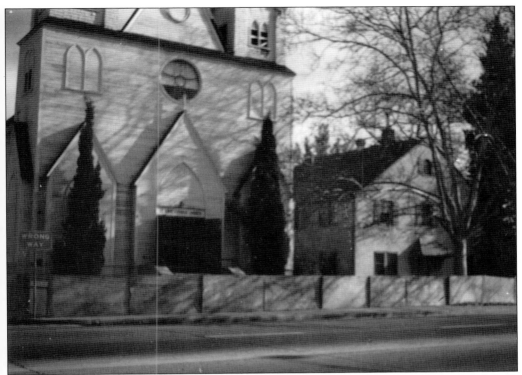

The parish on Grant Street, shown in the early 1960s, served the parishioners until the church built a bigger complex, including Saint Rose School, on Vine Avenue. As the membership of the church continued to grow, a rectory for the residence of the priest was built, seen to the right of the church. The site of the old Catholic church is now the site of the Roseville Civic Center, built in 2002.

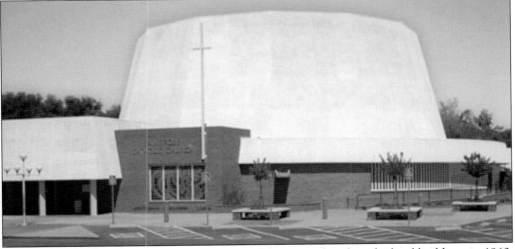

Saint Rose of Lima Catholic Parish broke ground for a new church and school buildings in 1960. The church, located at 615 Vine Avenue, opened with its first liturgy, a midnight mass, in 1966. A diverse community of many cultures attends Saint Rose, leading to their motto, "One Parish, One Community, One Faith." The parish and the parish hall complex, completed in 1981, is pictured here as it appears today.

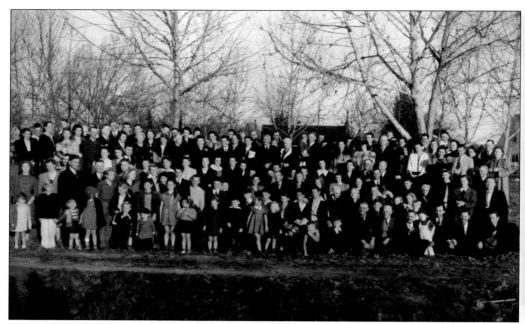

Groundbreaking ceremonies were held in 1942 for the Church of Jesus Christ of Latter-day Saints first Roseville building. The land had been purchased in 1930 with the assistance of real estate agent L. Leroy King. The church building for the Mormons would fill the block at 700 Douglas Street between Franklin Street and Park Drive.

The Church of Jesus Christ of Latter-Day Saints building was dedicated on March 12, 1944, as Roseville's First Ward. After the building was no longer used as a chapel, it remained empty for many years. The building is now the Studio 700 Center for the Arts, which serves the community's adults with special needs.

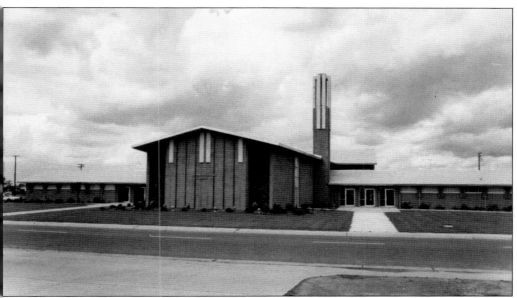

On May 17, 1970, this chapel at 211 Estates Drive was dedicated as the LDS Second Ward. It became Roseville's First Ward after the closure of the first building on Douglas Boulevard.

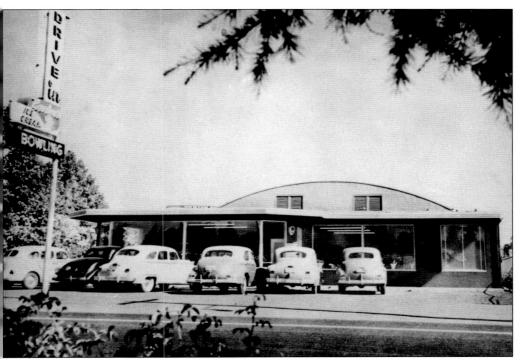

Not all churches plant their roots in new buildings. The Abundant Life Fellowship moved into the old Roseville Bowling Alley at 706 Atlantic Street in 1989. Over the years, the congregation has extensively remodeled the original building as the membership has increased. A three-story building was erected in May 2001 as the new sanctuary that seats 1,100.

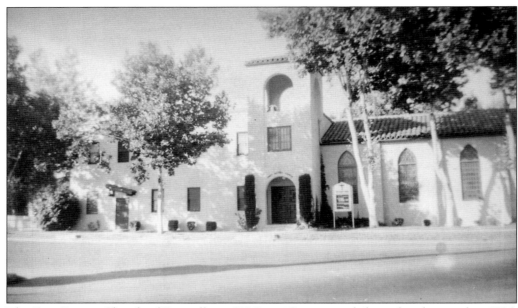

The First Baptist Church of Roseville at 628 Royer Street was dedicated and opened in 1936. The building remains standing today at the corner of Royer Street and Douglas Boulevard, and is home to Clear Voice Ministries Church of God in Christ.

A photographer snapped this shot inside the First Baptist Church of Roseville on Royer Street on February 10, 1952. Reverend Floyd Brown delivered the sermon from the pulpit that day.

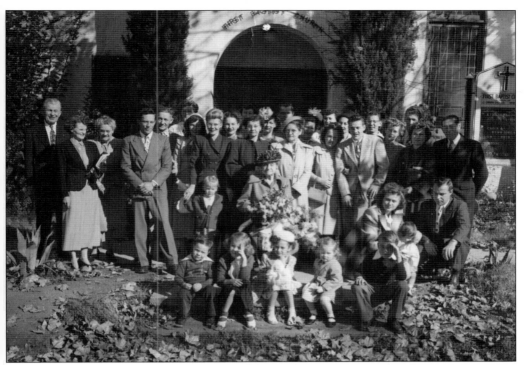

Most churches are busy with activities all week long. The First Baptist Church was no exception. A very special family birthday party was held at the church in 1946. The birthday girl, seated with flowers, posed for a photograph in front of the church with all of her family and friends.

Education in the early days mostly involved parents instructing their children at home. In 1857, efforts began to establish a permanent public school. Meetings were held at area ranches, and at one of these meetings, Thomas Dudley offered his barn for a temporary schoolhouse. Edwin Shellhouse volunteered to be the teacher. The one-room wooden school was built in 1872 near the corner of today's Atlantic and Grant Streets.

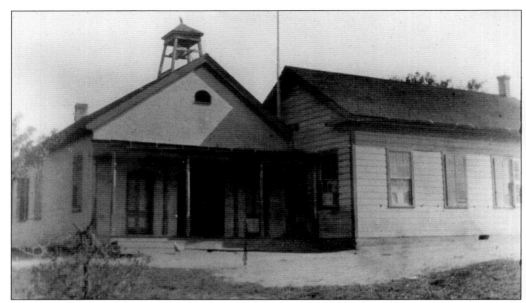

Fifteen students were required to form a school district in California. With 40 students, Roseville School District came into being on May 3, 1869. The first permanent school building cost more than $1,600 to build in 1872. It was called Pioneer School. A second one-room schoolhouse was built in 1879 to accommodate the growing number of students. The $2,000 brick building on the left was built next to the old wooden school.

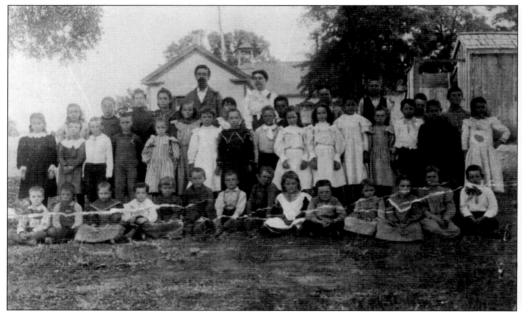

The students were educated in the two one-room schoolhouses located by the railroad tracks alongside Atlantic Street. Principal George Simpson and teacher Blanche Phillipi are shown with the children who attended the Pioneer Elementary School in 1894. Students in first through fourth grades took their lessons in the wooden school building, while fifth through eighth grade classes were held in the new brick building.

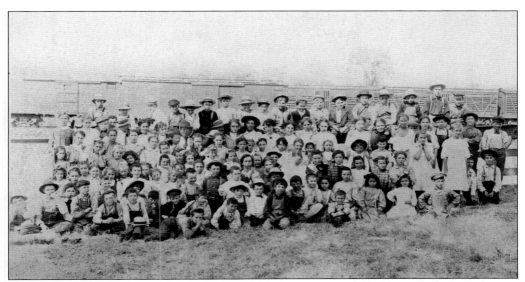

The number of registered students continued to increase, as seen in this class photograph from the Pioneer School's 1905-1906 school year. (Note the rail yard behind the students.) By 1907, 154 students attended school in the two small classrooms. Three years later, Roseville's population had increased dramatically, and its number of school-aged children had reached 480.

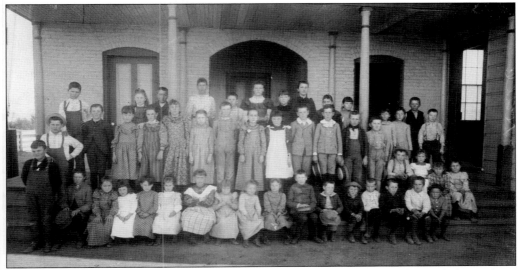

This is one of the last class pictures taken at Pioneer School. Blanche Phillipi and the students stand in front of the brick building in this undated photograph. By 1910, with inadequate space to hold the more than 400 children, town leaders decided to erect two new school buildings that year.

Two identical schools were built on opposite sides of the railroad tracks so that the children would not need to cross the rail yard. Oak Street School was built on the south side of the tracks and was ready for classes by the fall of 1910. The school building faced away from the railroad tracks and had an Oak Street address.

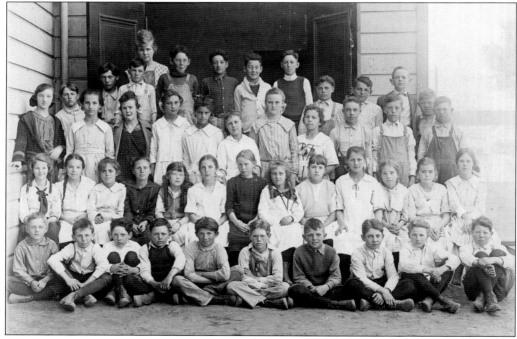

Oak Street School (referred to by some as Vernon Street School) bustled with children and classes from 1910 to 1925. This class picture, taken in 1918, has the students gathered with their teacher, Rachel Scott Nigel. Oak Street School was torn down in 1925 after a different building was constructed in the same block, facing away from Oak Street, with a Vernon Street address.

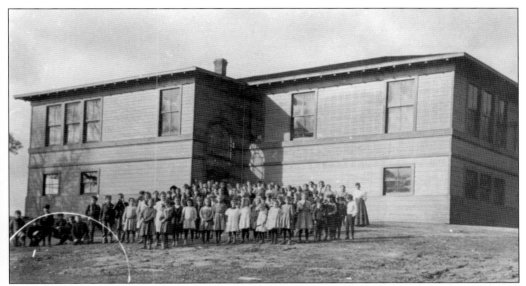

The other school was built on the north side of the railroad tracks and was ready for students by the fall of 1910. The Main Street School in Roseville Heights around 1920 was identical to the Oak Street School. Both of the two-story schools had the same floor plan. The lower level was used for the older boys, while the upper level was divided into several classrooms.

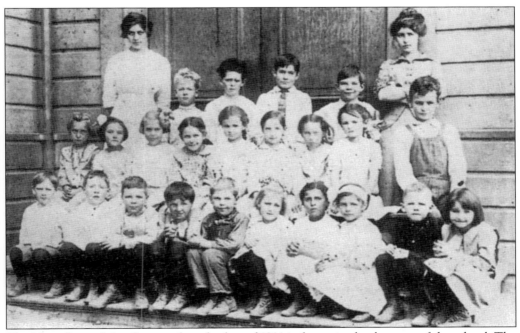

The Main Street School's second-grade class of 1914 is shown in the doorway of the school. The twin school on Main Street was filled with students and activities from 1910 to 1935, 10 years longer than the Oak Street School. The outdated Main Street building was finally removed after Woodbridge School opened for students. Weber Park, now located on that site, features a basketball court and a baseball field.

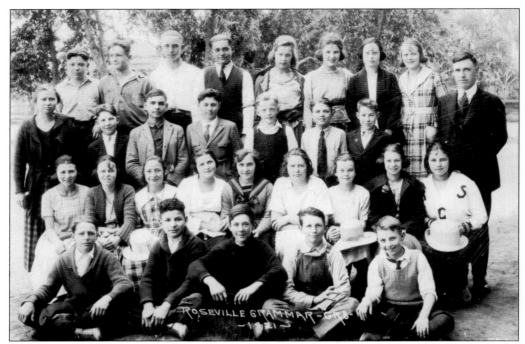

This 1921 photograph of an eighth-grade grammar school class did not have any student names or even a school name. The only two schools in Roseville in 1921 were the Oak Street School and the Main Street School.

Roseville's population doubled to 4,500 by 1920, and the students kept coming. Atlantic Street School was built in 1922 as the city's third grammar school. It became a middle school in the late 1950s (for sixth through eighth grades) until its closure in the 1960s. Adelante Continuation High School, established in 1966, was moved into the old Atlantic School facilities in 1989, after much-needed renovation.

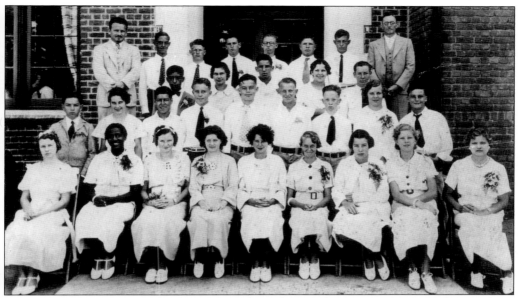

Here is the Atlantic Street School's eighth-grade graduating class on June 11, 1935. These students would be freshmen at Roseville High School in September.

The marching band at Atlantic Street School poses here in 1955, dressed for competition. Roger Blay enjoyed teaching music classes to the band and choir. He directed the school performances and prepared the groups for travel to music competitions all over Northern California.

Vernon Street School was built facing the railroad tracks on the same site as the Oak Street School. Vernon Street School replaced Oak Street School, which was torn down after completion of the new school. The new one-story school building had a Vernon Street address and was dedicated on May 15, 1925. Vernon Street School was closed in 1974 because it could not comply with California school safety requirements.

Teacher Lucille Anderson is photographed with her second-grade class in 1949. The students are dressed in their Sunday best, and the photographer has carefully posed all 28 students in front of the Vernon Street School entrance.

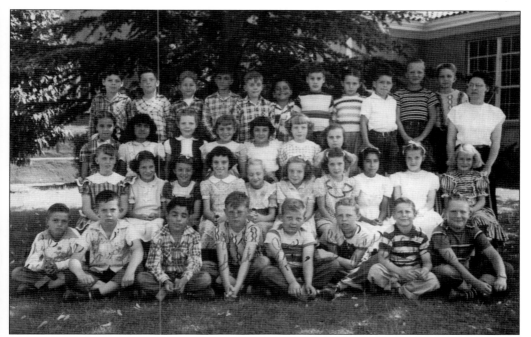

Margaret Trimble's third-grade class was photographed in 1950 on the front lawn of Vernon Street School. Class sizes were increasing proportionally to the city population. Trimble had 36 students in her classroom in 1950. The last 10 years had recorded an increase of 2,000 residents in Roseville.

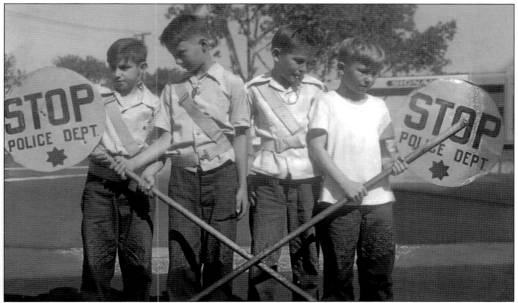

Vernon Street School was located by two busy streets. It was an honor to be selected as school crossing guard for either Vernon or Douglas Street. These boys took their jobs seriously, making sure children crossed the streets safely. The Rock purchased the Vernon Street School building and property to build a church for its congregation. When the building could not pass inspections, a new church building was constructed at 725 Vernon Street.

A second one-room school building with a belfry and a new school bell was added to the Pioneer School in 1879. The two new schools were built in 1910 without bell towers, so the bell was made a fire alarm bell at the Lincoln Street railroad crossing. Woodbridge Elementary School, completed in 1935, included a belfry, which once again allowed the bell to ring on school days.

The Woodbridge Elementary School at 515 Niles Avenue replaced the old Main Street School, which was subsequently torn down. Construction started in 1934; the school was dedicated December 1, 1935. Woodbridge Park (formerly Sierra Vista Park), and the new school both honor Dr. Bradford Woodbridge's 23 years of service as Roseville mayor and city council member.

September 2, 1912, was the first day for classes in Roseville High School. Prior to that, students traveled to Auburn or Sacramento to attend high school. Upstairs in the Golden Eagle Saloon, and later the Doris Theatre across Vernon Street, were used as the secondary school classrooms. An unexpected 51 students registered for classes that first day, and the enrollment totaled 85 for the 1912-1913 school term.

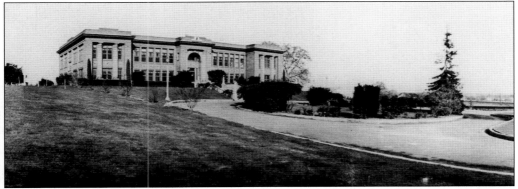

The new home for Roseville High School was ready for students on January 3, 1916, and the official dedication was held on Sunday, January 18, 1916. The entire community came to celebrate the new "high school on the hill." The number of students registering for classes increased each year. The enrollment of students on September 17, 1918, numbered 118, including 62 freshmen, 28 sophomores, 19 juniors, and 9 seniors.

The development of quality secondary education in Roseville can be credited to the devotion of two individuals. Cora Woodbridge immersed herself in the civic affairs of Roseville, and was president and founder of the Women's Improvement Club. Edwin C. Bedell, known as the father of Roseville Union High School, devoted his life to establishing the Roseville Union High School District, and advancing education by serving on educational boards and committees.

School buses were a luxury that was not always available. Even after the district had buses, many students still had to walk a great distance to get to school. This photograph shows a school bus for Roseville Union High School in 1929. The school bus station in recent years has been located on Berry Street by the high school, and provides transportation for students in grades kindergarten through 12.

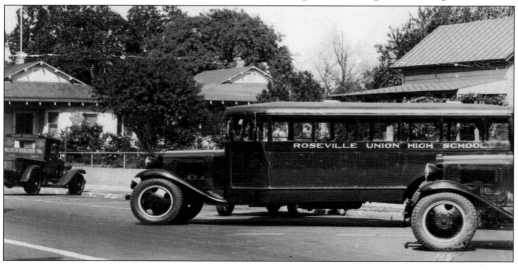

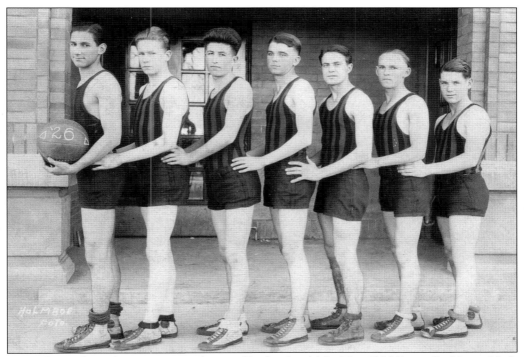

Sports have always been an integral part of high school life. The 1926 Roseville Union High School boys basketball team is pictured here: (from left to right) Joe Palace, John Decatur, Roy Falltrick, Roy Stomm, Danny Cortopassi, Alek Hageman, and Grant Perry.

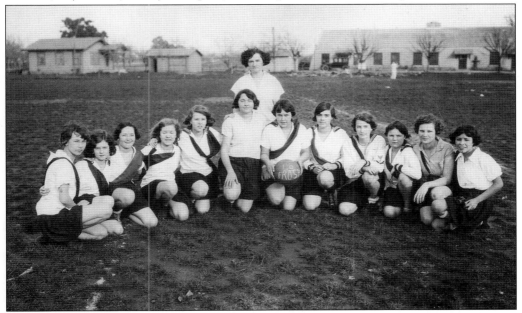

The Roseville Tigers had the school colors of orange and black from the very beginning of Roseville High School. School spirit and sports were just as important to the girls as they were to the boys. The 1928 girls freshman basketball team poses here out on the school field, ready to compete.

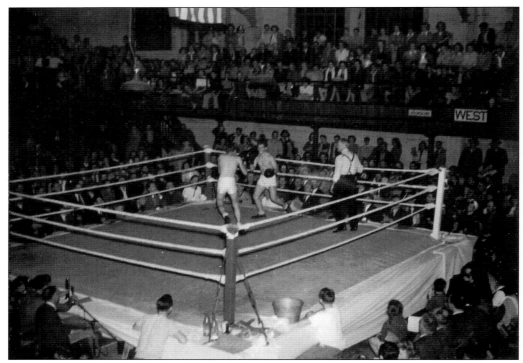

Boxing was one of the most popular sports in the 1940s. The gymnasium for Roseville High, completed in 1926, was fully packed with supporters, family, and friends for these events. The boxing team drew a large audience from the community that filled the gymnasium ready for Friday night entertainment.

BOYS' BOXING SCAMPER

Roseville Joint Union High School Gymnasium

Friday, March 16, 1945 8:15 P.M.

FIGHT CARD

Heavyweight Blindfolded Match
Cup donated by Paolini Bros. Service Station

Chuck Howard (174) Robert Holihan (185)
George Mandich (188) Tony Segarra (156)
Robert Glines (220) Joe Gemignani (180)

1. Erwin Zents vs. Fred Kuhlman
 (140) (143)
2. Sam DeCarlo vs. Don Kamrar
 (98) (97)
3. Layland Friberg vs. Claude Maxfield
 (153) (148)
4. Chriss Georgis vs. Alfred Bustos
 (132) (135)
5. Eddie Bond vs. Arden Bolin
 (140) (142)
6. Martin Hall vs. Robert Arribalsaga
 (125) (122)
7. Benny Wade vs. Angelo Demas
 (128) (122)
8. Hanford Crockard vs. Harry Daniels
 (153) (148)
9. Gus Demas vs. Ferd Galvez
 (135) (144)

INTERMISSION

10. Robert Palo vs. Sam Demas
 (105) (106)
11. Clair Combs vs. Bill Santucci
 (140) (140)
12. Peter Riolo vs. Morris Donaldson
 (132) (128)
13. Ken Kamrar vs. Richard Galvez
 (122) (128)
14. Bob Hunter vs. Vernon Davis
 (145) (143)
15. Phillip Kister vs. Allan Hanisch
 (114) (114)
16. Jim Inglett vs. Richard Penney
 (132) (132)
17. Bud Robinson vs. Tony Segarra
 (154) (156)
18. Tom Wukman vs. Greg Rowe
 (165) (175)
19. John Aimo vs. J. B. Davis
 (171) (179)

Lightweight Blindfolded Match
Cup donated by Glen Coberly—Plymouth-DeSoto Dealer

Ferd Galvez (144) Angelo Demas (122)
Fred Kuhlman (143) Alfred Bustos (135)
Erwin Zents (140) Alfonso Garcia (115)

OFFICIALS

Principal and Superintendent J. W. Hanson
Judges Julius "Brick" Paolini, J. B. Erickson
Harold "Bizz" Johnson
Erickson Sportsmanship Award Orrin J. Lowell
Reverend W. A. Ellis, Willard Dietrich
Referees Senator Jerry Seawell, Joe Royer
Bill Rewe, Ned Kay
Timekeepers W. J. Fitzgerald, Don Winter
Announcer R. E. Arp
Faculty Supervisors R. H. Moeller, Sam Benidettino
Ring Fred Coburn

OFFICIALS

Usherettes: Josephine De Fuentes, Chairman; Molly Jesperson, Carnation Basque, Elise Moeller, Patsy Harjes, Janet Gregory, Maynee Granger, Betty Williams, Coralie Fiddymeant, Sylvia Rastler, Joyce Trimble, Annette Salardino.
Concessions: Beverly Broderick, Chairman; Avalon Barusch, Ann Bilich, Sue Novi, Ann Davis, Muriel Elster, Ardith Noakes, Betty Freeman, Nina Pierce, Charlie Schubert, Josephine Cassara.

We wish to thank M. J. Royer, J. B. Erickson, J. B. Paolini and Glen Coberly for their help in making the Boxing Scamper a success.

Fight cards were handed out to the crowd for the Roseville High School Boys' Boxing Scamper. Community businesses that supported the event found it to be great advertising. Notice that a spectator has circled the winners on this card from the matches held on March 16, 1945.

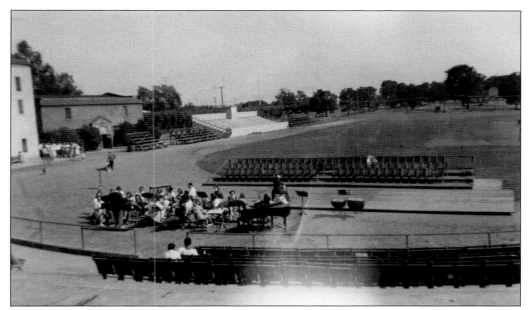

The Roseville High School Amphitheater in the foreground was completed in 1936. On the left, the gymnasium built in 1926 is seen next to the fine arts building. The concert band is shown rehearsing with the seniors, who are entering from between the buildings, for the 1943 graduation ceremony. A swimming pool has since replaced the art building, and a library and classroom wings fill the football field seen here.

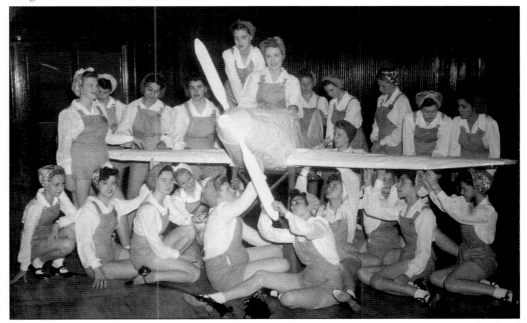

The Girls' League at Roseville High School put together an exciting variety program each school year. The show was performed for two nights, showcasing a large selection of musical, dance, skating, gymnastic, and dramatic routines. The girls pictured here performed a "Rosie the Riveter" dance routine during the 1944 Girls' League Show, *Hit Parade*.

Bernice "Ma" Bradford retired in 1941 after teaching English for 18 years at Roseville High. The poem she wrote for her beloved school has become the Alma Mater of Roseville High School. From far and wide, students and community lovingly refer to their high school as the "high school on the hill." The venerable building erected in 1915 was replaced in 1970.

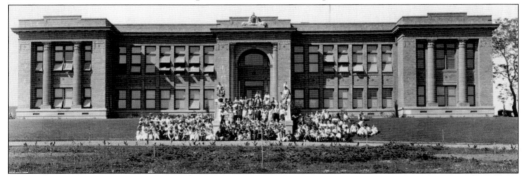

A Song for Roseville High

There's a high school on a hilltop
In the land where roses grow;
Every breeze of morning greets her
From the Sierra capped with snow.
Roseville High, our Alma Mater,
To our hearts thou'rt ever dear,
And we'll cherish thy remembrance
Through every coming year.

We'll sing a song to Roseville High,
And sing it with a will.
Where'er we turn
Our hearts will yearn
For the High School on the hill.

Five

AGRICULTURE

THE GOLDEN LAND

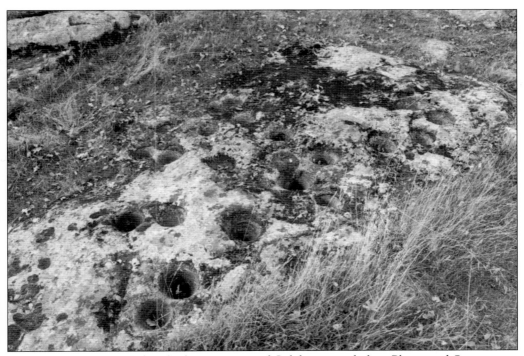

The Maidu Indians inhabited a large portion of California, including Placer and Sacramento Counties, prior to the arrival of the pioneers. The valley provided an abundance of fruits, fish, and oak trees that the Maidu enjoyed. Ground acorns were the main staple of their diet. The mortars or grinding rocks shown here are preserved in the Historic Maidu Interpretive Center, located in east Roseville on part of the old Johnson Ranch.

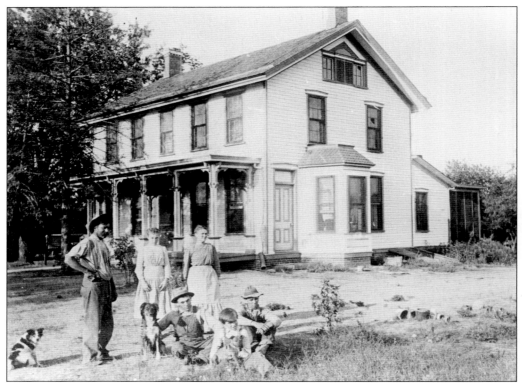

The families who pioneered the Roseville area were comprised of unsuccessful gold miners and others who wanted to work the land. In 1852, Martin Shellhous settled on 240 acres to raise cattle, grow grain, and maintain vineyards and orchards. The Shellhous family's land became one of the area's oldest continuously operated ranches, closing only upon the 1960 death of Martin's son Earl, shown here with his family.

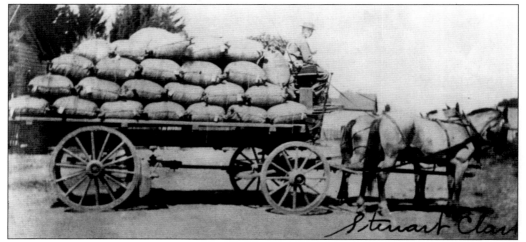

The variety and bounty from the farmer's fields and orchards made it possible to earn a living. Most ranchers also grew wheat and grains for themselves, shipping the excess for a generous profit. In this image, a load of almonds is on its way to the train depot for shipment to the Sacramento area. Other fruits, grapes, and nuts were readily grown and shipped by rail.

John "Jack" Doyle chose a homestead in the 1860s for growing grapes and harvesting wheat, part of which has since become the location of Roseville Square. He purchased many choice parcels of land in and around Roseville in the 1890s, when businesses were floundering. Pictured in the wheat field around 1950 are some Doyle descendants at harvest time. From left to right, they are Jack's son Bill Doyle, and Bill's sons Jack, Bob, and Tom.

James Kaseberg came to Roseville in 1864 and eventually grazed 11,000 sheep. He continued to buy more and more land until his ranch spread across 50,000 acres, reaching from Roseville to the Sacramento River. Around 1892, Diamond K Ranch produced 200 tons of wheat for shipment. The family ranch (above) has since become Diamond K Mobile Home Estates. The mansion still stands, and is rented out for social events.

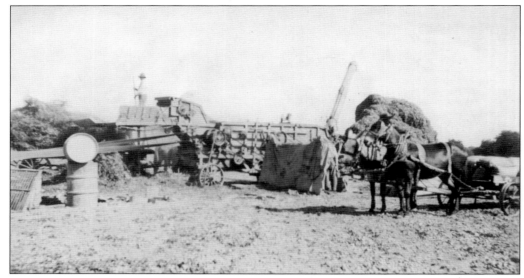

Walter Fiddyment was one of the early pioneers of Roseville who purchased his first 80 acres in 1879, at the age of 29. He added 160 more golden acres and became one of the leading grain and stock ranchers in Placer County. This photograph was taken of one of the fields during the wheat harvest in 1902. Fiddyment remained active in agriculture, the church, and local business his entire life.

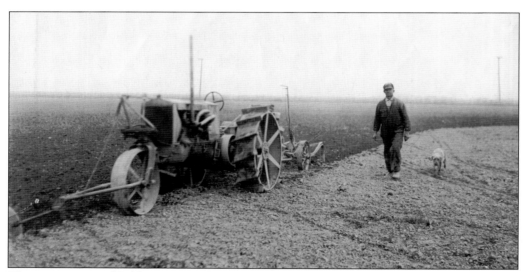

This rare picture of Fiddyment with his dog in 1918 shows him taking a leisurely walk to look over the newly plowed portion of one of his many wheat fields. His new modern plow made it possible to turn the soil in his expansive ranch without the use of horses.

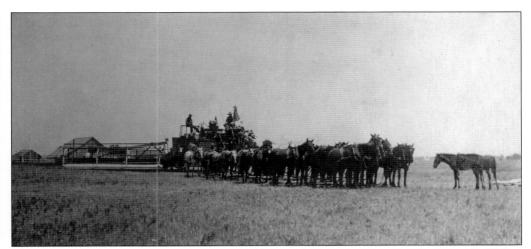

It took a large team of horses to work the land before there were tractors to do the work. Walter Astill and his ranch hands are seen in the early 1900s preparing to harvest the wheat crop. The extensive Astill Ranch was in and around what is now the intersection of Vernon and Cirby Streets.

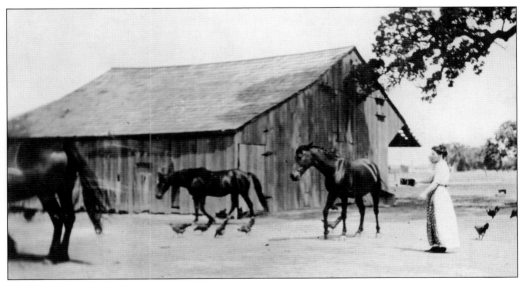

Around 1920, Mildred Astill is moving some horses out to pasture after a hard workday on the ranch. Not only were horses used to pull the farm equipment, but they also provided transportation and came to the rescue when city slickers had a mishap during the rainy season. (While traveling from Roseville to Sacramento, cars frequently got stuck in the mud while taking a shortcut through the ranch.)

The first commercial orchards were planted by Lewis Leroy King Sr. in 1890. The King Ranch produced a great variety of fruits including cherries, peaches and plums, as well as almonds. The ambitious King also established the first real estate and insurance business, with his first recorded sale in 1891. Pictured are Lelia King and Carrie Keehner in an orchard that was replaced by the Cherry Glen housing development.

The Placer County Winery was founded in 1906 at the end of Grant Street next to Dry Creek. Even though the winery was destroyed by fire on August 18, 1908, it was completely rebuilt that same year. Roseville's citizens considered the winery second only to the railroad in its importance to Roseville's economy. Operations continued even after another fire, until Prohibition shut it down for good. The fire department now occupies 401 Oak Street.

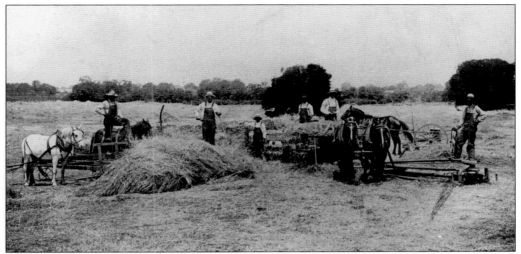

Francis "Frank" Crowder settled on 50 acres just west of the Roseville city limits, where he planted wheat, orchards, and vineyards. Crowder was the director of the Railroad National Bank in Roseville, established in 1912. He also was very involved in local politics. Today, Crowder Lane cuts through the old ranch off of Baseline Road.

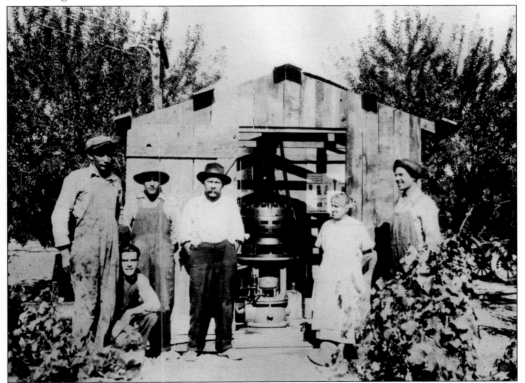

Some local ranchers and farmers like Louis Bianco didn't have enough land to earn a living. The railroad offered jobs with a paycheck to many farmers who needed to supplement their income. This photograph shows Bianco in front of his shed, fourth from the left, with his family as they were attending to daily chores.

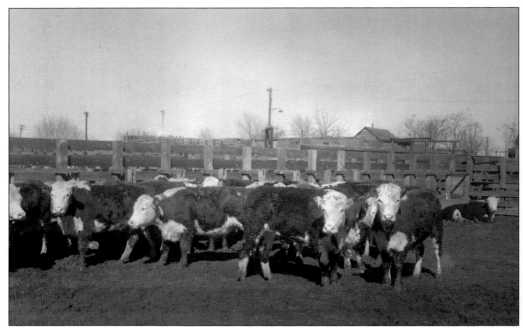

Cattle were herded to the livestock yards next to the railroad for auction or transportation. Some ranchers would load their herd on cattle cars, to travel by train to the mountains, for summer grazing. Local ranchers had permission to graze their livestock on government land during the summer, thus saving the feed on their ranch for winter grazing.

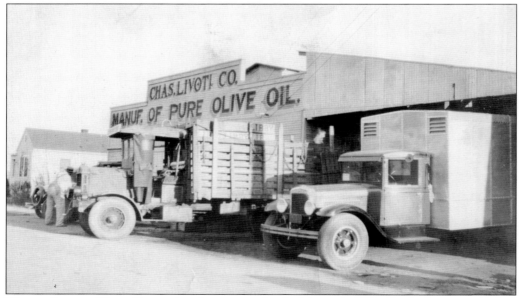

The small town of Roseville continued to grow and make history. In 1921, Charles Livoti established a business to ship grapes, olives, and other fruits. By 1925, Livoti had opened a modest olive oil manufacturing plant on Tahoe Avenue. The Charles Livoti Company grew to be one of the largest producers of olive oil in the state of California.

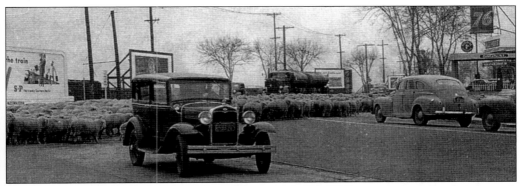

It was a common occurrence from the 1920s through the 1960s to see sheep herded through downtown Roseville. Twice a year, ranchers traveled to the livestock yards by way of Rocky Ridge Road to Douglas Street (now Boulevard), and then down Vernon Street. This photograph shows how the river of sheep would stop all vehicle traffic. When the sheep passed the school, distracted schoolchildren were allowed to watch the sheep parade before resuming studies.

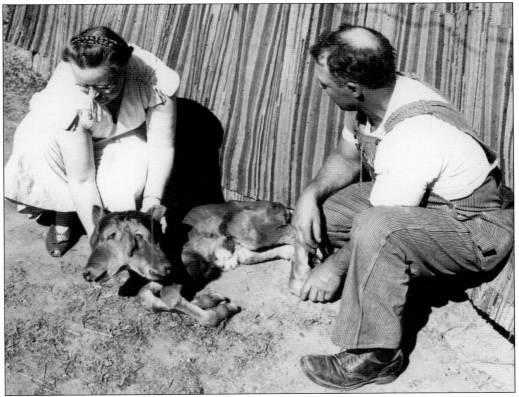

Viola (great-granddaughter of Zacariah Astill) and Erwin Wendt are seen examining the two-headed calf that was born on their family ranch. The calf did not live very long, but Erwin had it stuffed and displayed it in the family's living room. A fire on December 12, 1951, consumed the entire ranch house and its contents, including Christmas presents and the stuffed calf. Thankfully, the family escaped without injury.

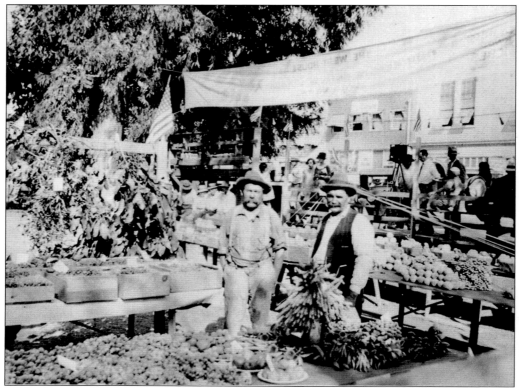

F. B. Rossi and his friend Louis Bianco are shown here in 1927 selling some homegrown produce in town. Growers commonly sold their produce in the lot at the corner of Vernon and Washington Streets. The Roseville Chamber of Commerce and the city sponsored public street fairs in 1935 and 1936 on a blocked-off Vernon Street. The tradition continues with Downtown Tuesday Nights, held from May to July each year.

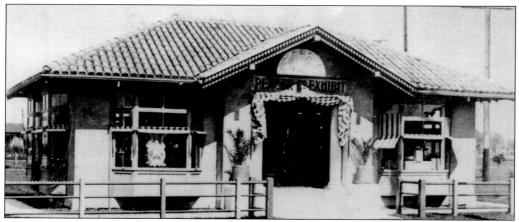

The Placer County Exhibit Building, built in 1915, originally stood near the depot for displays of local agriculture. It was hoped that railroad travelers would like what Roseville had to offer and decide to stay. In 1930 the Roseville Chamber of Commerce relocated the building to 700 Vernon Street. The Chamber built a new modern building at 650 Douglas Boulevard in 1988. The old building has housed several businesses since then.

Six

COMMUNITY LIFE
MAKING TIME FOR FAMILY AND FRIENDS

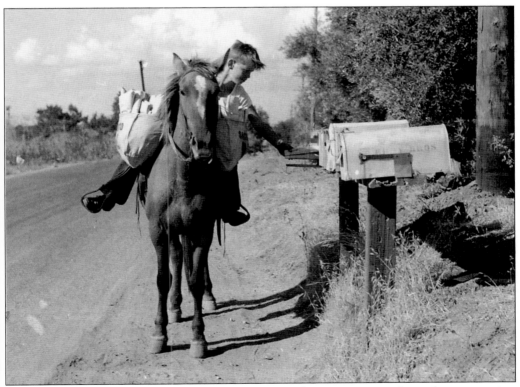

Even after automobiles became affordable, horses were the most common form of transportation around Roseville. In the farming and ranching community, life revolved around family, friends, and horses. This young man delivering the newspaper probably completed his route more quickly than he could have in a car driven by a parent—and he had fun.

One of Roseville's early enterprising businessmen, Thomas Berry built his family home near the railroad crossing of Atlantic Street and opened the town's first barbershop and the Corner Saloon around 1875. These buildings were all near the property where the high school would be located many years later. The railroad crossing and the street are now named in Berry's honor.

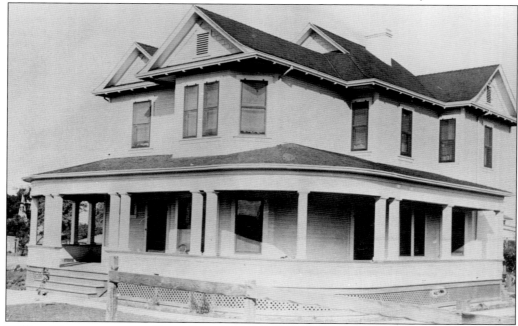

William Haman was sent to Roseville in 1905 to establish and operate the Placer County Winery, which he did until Prohibition closed it down in 1918. Haman was elected one of the first city trustees in 1909. He is remembered for spearheading the effort to acquire the land that today is Royer Park. The Haman House, built at 424 Oak Street in 1910, became the city-owned Roseville Arts Center in 1969.

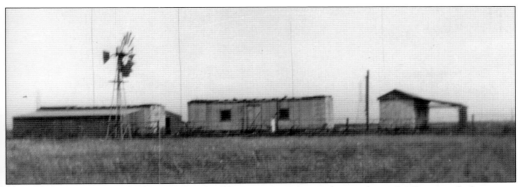

Not all houses in Roseville are fancy buildings or constructed out of wood. The people living in the house make it a "home." Some inventive families took advantage of the discarded refrigerated railroad boxcars and converted them into residences. This house, photographed in 1956, might have been the inspiration for the modern-day modular home.

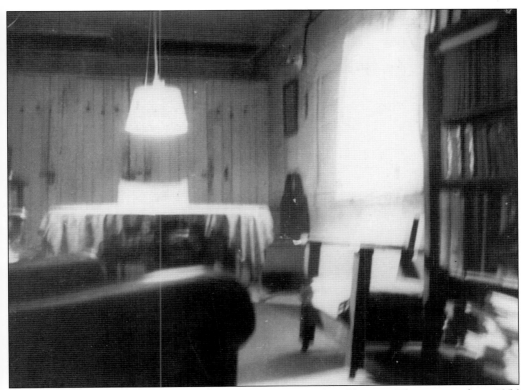

A person could make a very comfortable home out of a railroad boxcar. This picture from 1956 shows the living and dining areas, complete with electric lighting. The well-insulated refrigerator boxcar made this family a warm and comfy home. A window cut into a wall allowed sunlight to brighten the room during the day.

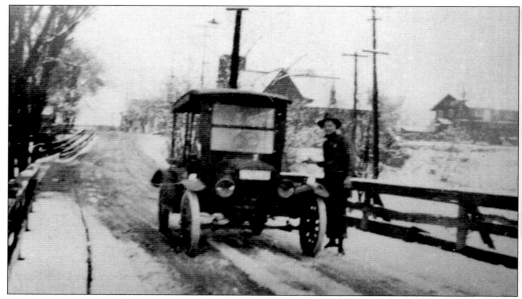

Snow is rare in Roseville. The driver of this delivery truck wanted a snapshot of this unusual sight in 1912. The snow on the Lincoln Street Bridge was deep enough for drifts and tire tracks. The newly built Presbyterian Church on Lincoln Street can be seen behind the vehicle.

Zacariah Astill came to Roseville in 1851 and built a ranch house on the land he received through a land grant issued by Pres. James Buchanan. This photograph documented the heavy snowfall in 1921 on the family ranch, located where today's Cirby and Vernon Streets meet.

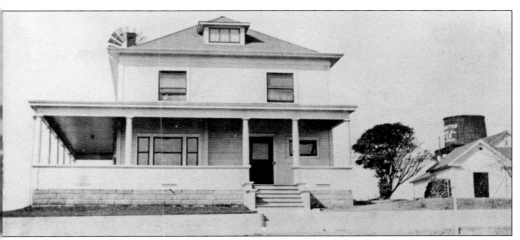

Alexander McRae came to Roseville in 1876 as a farmer and horse breeder. In 1905, he turned to business and real estate, and he handled land acquisition for the railroad expansion. McRae built his second house on Jones Street, shown in 1907, and soon after built the McRae Building where his first home had been on Main Street. McRae became involved in banking and in selling parcels of his ranch as the town population exploded.

McRae Opera House was built in 1908 as the top floor of the McRae Building. As the cultural center of town, many events have been held in the hall through the years, including live theater, band concerts, high school graduations, and boxing matches. At one time it was a skating rink, and even housed the *Press-Tribune* newspaper offices. Despite its name, McRae Opera House has never held an opera.

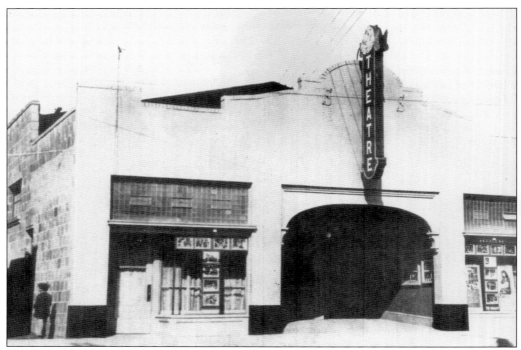

The Rose Theatre on Main Street was built in 1915, next door to the M. B. Johnston store. Even though it is considered by many to be Roseville's first theater, the Doris Theatre on Vernon Street was built first. Roseville's second theater had a name change from Rose Theatre to the Roxie Theatre in 1936. The Roxie was never rebuilt after a fire in the 1940s consumed the building.

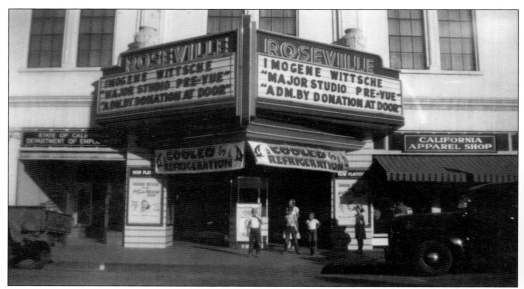

The Roseville Theatre, built in 1926 on the ground floor of the new Masonic Temple Building, was the town's third theater. The movie theater was a popular, affordable diversion in the Depression and war years. The Magic Circle Theatre has been located at 241 Vernon Street since 1987, offering acting workshops and quality live performances.

The program distributed for the New Roseville Theater in October 1932 shows the wide variety of movie pictures offered. Women would receive a free jar of face cream on Thursdays just for attending. Admission for children was only 10¢, which made the theater a favorite hangout for kids.

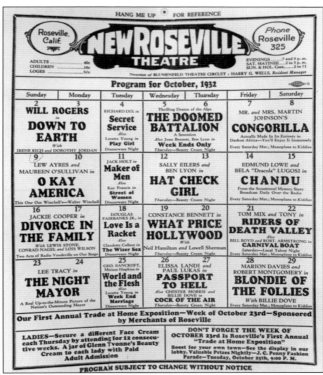

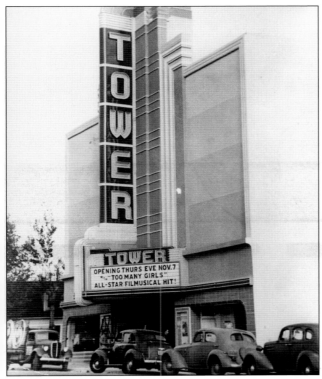

The Tower Theater opened its doors to the public on November 7, 1940. After years of sitting empty, the building was donated to the City of Roseville in 1989. The city, in conjunction with Roseville Arts, refurbished the theater as a community venue. It reopened in 2003 as a 260-seat theatre-in-the-round for performances by the Magic Circle Theater organization.

The oldest fraternal organization in the city, Roseville Odd Fellows Order No. 203 was instituted in 1872. The officers in this 1950s image are, from left to right, (first row) George Gates, Roy Fisher, James Crail, Emmitt Sinclair, and Lynn Hubbard; (second row), Lyle Darling, Charles Wimberly, George Pielenz, Elmer Wolff, and Mike Kolak; (third row), Walter Evans, Cecil O'Rell, Francis Astill, Oscar Hanisch, and George Morey, and (representing the military branch) Lester Astill.

Minerva Rebekah Lodge No. 72 was instituted in April 1883 as an auxiliary of the Independent Order of Odd Fellows. Here, Roseville's oldest fraternal organization for women is shown installing its officers around 1950. The Odd Fellows sold the Pacific Street building in 1942 and moved into the newly purchased Women's Improvement Clubhouse at 327 Main Street. In 1988, they purchased 412 Washington Boulevard, their current meeting hall.

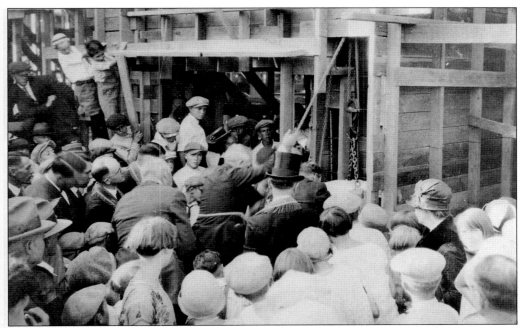

Roseville Masonic Lodge No. 432 was chartered in July 1912. Granite Lodge of Rocklin No. 222 merged with Roseville in 1919, and No. 222 became the Roseville lodge number. The cornerstone was placed at the corner of Vernon and Washington Streets for the temple and theater that were dedicated on May 1, 1926. In the more than 80 years since, the Masons have continued to meet upstairs in their building at 235 Vernon Street. The Magic Circle Theater is downstairs.

The Roseville Masonic Lodge initiated the first members of the Demolay youth chapter in December 1933. This October 1961 portrait shows, from left to right, (first row) Arnold Joyce, Jerry Schaffer, Ken Easter, Bill Winsell, Harold Croy, Mike Duggan, Bill Johnson, Larry Thorpe, and Dave Goodlow; (second row) Tom Bender, Dan Woolverton, Richard Ryan, Ed Flanders, Chris King, Mike McClure, Jessie Peacock, Bill Olson, Jack Gotcher, Irwin Jackson, and Ken Schaffer.

Roseville Host Lion Club, founded in 1925, is the longest-standing service club in Roseville. The Lions Lodge, located at 107 Sutter Avenue, continues to serve the community as well as house the active membership today. The Lions love to have fun while raising funds for scholarships and serving the community wherever they are needed. Shown here is the cast from the 1935 Lions' Variety Show—comprised of all men.

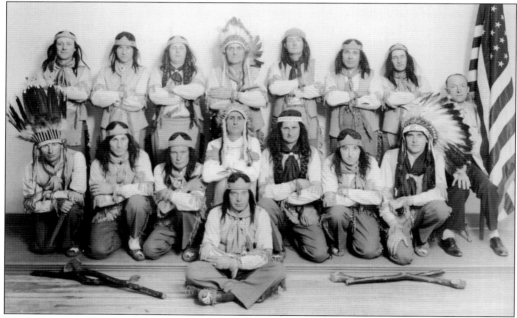

The Minneopa Tribe Order of Red Men's Drill Team was photographed in 1940. Pictured here from left to right are Harold Street (seated in front), Floyd Johnson, Steve Salardino, Luther Coilett, Hector Listello, John Macario, unidentified, George Lambert, and (second row) Manly Leavie, unidentified, Gene Garbolino, Earl Harrington, Bob Henderson, Frank Bianco, unidentified, and Thad Aiston (next to flag).

The Daughters of the American Revolution have been active in the Roseville area for many years, and are still an active service organization. Here Maude Perry, a DAR member, models the costume she wore for a special event. The group's members are all descendents of families who were a part of the American Revolution.

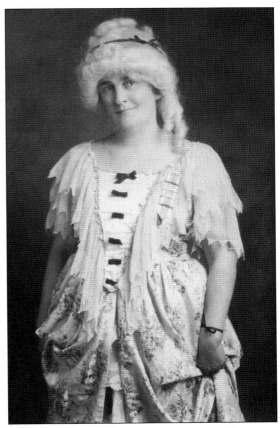

The Roseville Riders Club, below, was made up of local ranchers who enjoyed the pleasure of riding, in addition to working with horses on their ranches. The Junior Riders Club was started so that the children of the group could also ride. After a long hard work week, the riders and horses were ready for a parade competition, a weekend getaway, or an all-night dance by the American River.

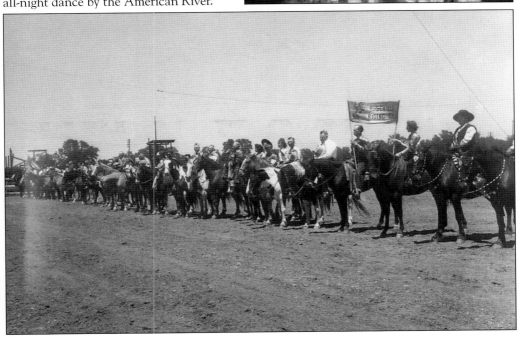

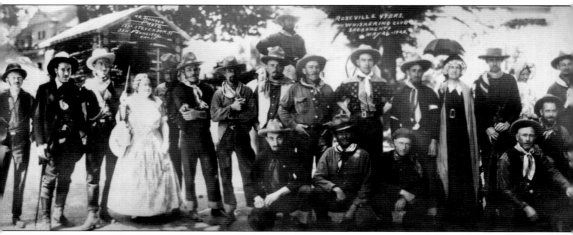

The Roseville 49ers Whiskerino Club had a group photograph taken on May 26, 1922. The group cleverly identified itself as a Roseville club with flowers (probably roses) on their banner, stretched out across the middle of the photograph, spelling out "Roseville." Being a part of a club is like having a large diverse family to have fun with. The 49er club members enjoyed the

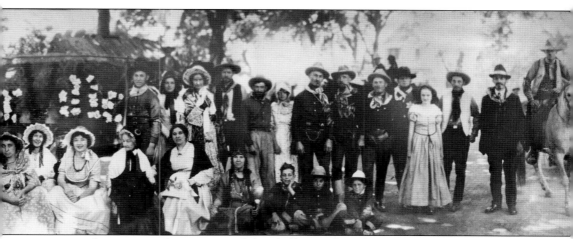

opportunity to dress in period costumes and the challenge of speaking and behaving how their characters would speak and behave. The experiences these club members shared would last a lifetime, and they continue to live on in the stories that are passed down through the generations to the present day.

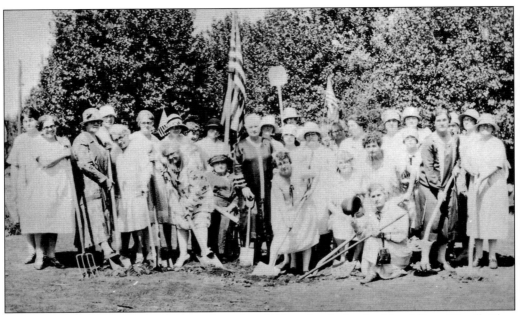

The Women's Improvement Club was formed in 1910 under the leadership of Cora Woodbridge. Some of their first efforts were to plant trees and flowers along the dusty roads to divert attention from the stark railroad yards and tracks. Bringing culture to the community was at the top of the club's list. They convinced the city that a library was needed to promote education and cultural interests.

Women's Improvement Club

::: BENEFIT VAUDEVILLE :::

McRae Opera House, Friday Night, Apr. 21

GENERAL ADMISSION TICKET, 35c

Reserved Seats at Roseville Drug Store

The Women's Improvement Club sold tickets to numerous types of events, including a vaudeville show, to raise funds for the improvement and beautification of Roseville. One of the biggest projects they took on was to promote the establishment and building of the local high school in 1915. The Women's Improvement Club is still active in Roseville, fund-raising and serving the community.

Cora May Woodbridge, shown here in 1911, was not only the wife of Dr. Bradford Woodbridge, she was a leader in the community and the state government. Cora was elected to the California State Assembly in 1922, and served as the first woman in the Ninth Assembly District from 1923 to 1929. The numerous shade trees in Roseville, Woodbridge School, and Woodbridge Park are a tribute to the civic-minded Cora and her husband.

The Grand International Association of Wives of Railroad Engineers is shown here in 1920. Since the railroad was the focal point of Roseville, there were a great many wives of engineers in the area. The GIA would gather for a variety of social activities that had nothing to do with the railroad.

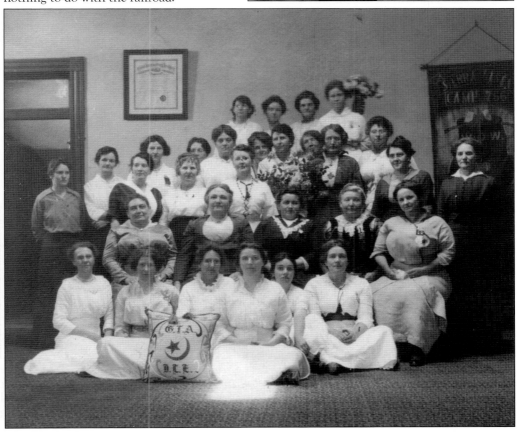

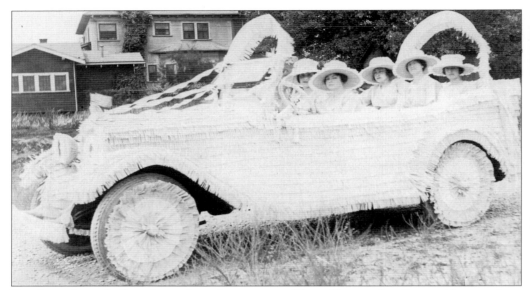

Parades and parade floats have always been a part of Roseville; parades allow residents to show their patriotism, celebrate the fair's arrival, and mark the beginning of the holiday season. In this 1926 photograph, Lady Firemen from the Brotherhood of Locomotive Firemen and Engineers are pictured in their parade float.

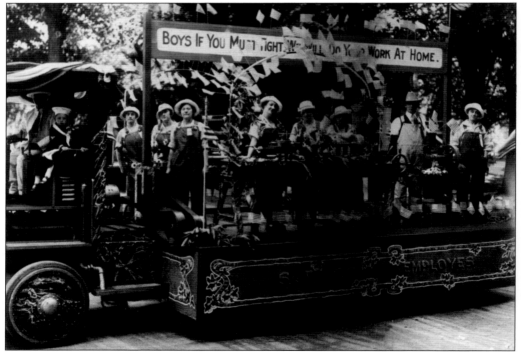

The female Southern Pacific Railroad employees on this float honored the SPRR men who were, or would soon be, serving in the military. This undated photograph is considered to be from World War I. The SPRR shaped everyday life in Roseville. In addition to providing many jobs, the railroad brought business to town. Railroad traffic even controlled the speed of travel from one side of town to the other.

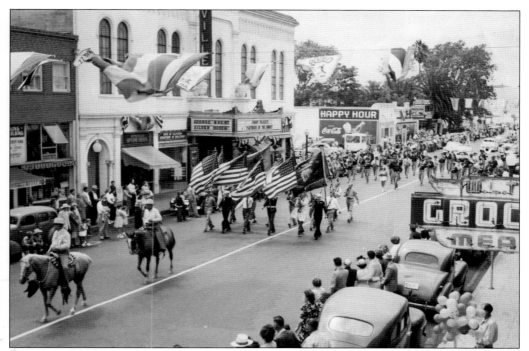

Roseville's favorite parades came during Fair time, the Fourth of July, and Labor Day. Horses, floats, and marching bands would illustrate Roseville's spirit as citizens paraded down streets that were themselves decorated with patriotic flags and buntings. As seen here in 1948, the parades created crowded sidewalks of excited spectators eager to wave their flags and applaud their family, friends, and neighbors.

What would opening day of the Placer County Fair be without kids and a parade? The Roseville Odd Fellows and Minerva Rebekah Lodge regularly participated in these events. This 1949 float declared that Roseville's children were "More Precious than Gold." Seen here inside the "gold" nugget are Jimmy Parker and Phoebe Wendt. At parade's end, their entry was awarded second prize for Best Float.

The Chamber of Commerce and the City of Roseville sponsored day-long street fairs in 1935 and 1936. There were food and game booths, as well as a dance to end the event. The front gates of the Placer County Fairgrounds first opened in 1937, providing a larger venue for the popular county fair. The yearly tradition continues, and the grounds located off of Washington Boulevard are busy year-round with a variety of events.

The fair's monkey and organ grinder were always a favorite with the children. The fair experience was not complete without feeding a peanut to the monkey. The monkey would hold out his little tin cup for the children to put coins in, and then climb up the organ grinder to deliver the coin. People of all ages could not resist the catchy tune and the monkey's antics.

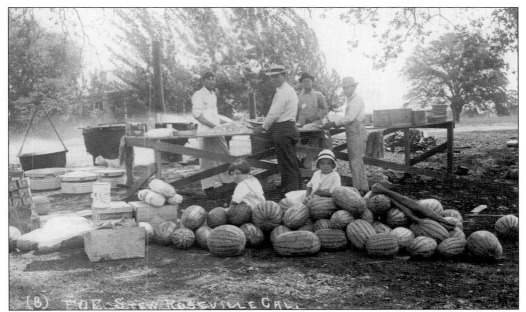

The Forest Oak Estates annual Cottontail Stew was a community favorite. Farmers, ranchers, and city folk would gather together to catch up on the year's events. In this image dated August 9, 1914, the rabbits are stewing and the watermelons are ripe: all is ready to serve a hungry crowd. The annual event was held in the area where the Sierra View Country Club now stands.

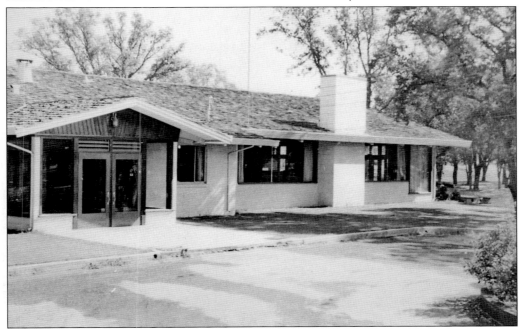

The game of golf was becoming popular in the 1950s, but there was no place to play in Roseville. The men called it "cow pasture pool" when they attempted to play close to home. Disgruntled, a group of men who loved the game got together in 1953 to form the Sierra View Country Club and build a golf course in town. This photograph shows the clubhouse, built in 1953.

The Roseville Athletic Club was comprised of local merchants who loved playing ball against other teams. This 1948 picture of the RAC basketball team shows, from left to right, (first row), Skip Padilla, Tommy Apostolas, and Bill Kolak; (second row) John Piches, Harold Ruggles, George Mandisch, and Manuel "Pro" Williams.

This Roseville Little League team picture from the 1950s shows Martin Clancy as the coach. Martin's father William "Bill" Clancy raised the money to install lights and a grandstand at the Roseville High School baseball field in 1949, which bears the name Clancy Field to honor him. Bill Clancy was an enthusiastic supporter of city and school athletics, and could be counted on to raise funds for projects.

Dave Roderick played for the Placer-Nevada Baseball League for 26 years. He started playing for the Rocklin Owls at the age of 17. Known as "Old Reliable," he was the winningest pitcher in the league's history. Roderick played for a number of different teams in the Roseville area, competing until he was 43 years young. In 2004, Dave Roderick Field was dedicated in his honor at Roseville's Lockridge Park.

The entire town turned out to welcome Pres. Harry S. Truman when his train made a brief whistle-stop in Roseville during his 1948 presidential campaign. Presidential candidate John F. Kennedy also made a whistle-stop in 1960. Vice-presidential candidate John Bricker spoke to Roseville voters during his own 1944 campaign visit.

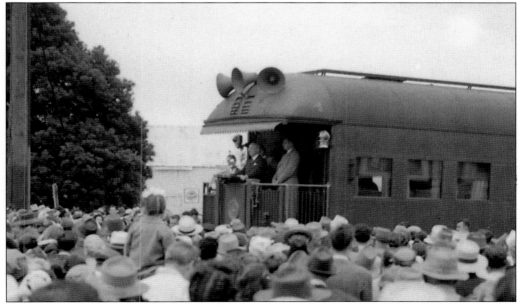

Boating or taking a dip in the Forest Oaks recreational area's artificial lake was a summer pastime enjoyed by many people. The man-made lake was located in the area that became the Sierra View Country Club. There wasn't much to do in the summer after chores were all through, so many families would pack up a picnic basket and meet up with friends to visit near or in the water.

Before there were any swimming pools in Roseville, there were always the creeks running through town to jump in. Boys were known to go skinny dipping on a hot summer afternoon. This photograph is evidence of the fun these rascals had cooling off in the creek. (If anyone can identify these characters, please contact the historical society.)

There would be no skinny-dipping for these girls. Most girls would put on their swimming suits before venturing into the creek to spend a lazy day relaxing and keeping cool. Some girls would simply remove their shoes and socks and lift up their skirts to wade in the creek for a quick cool-off after picking berries on a hot summer afternoon.

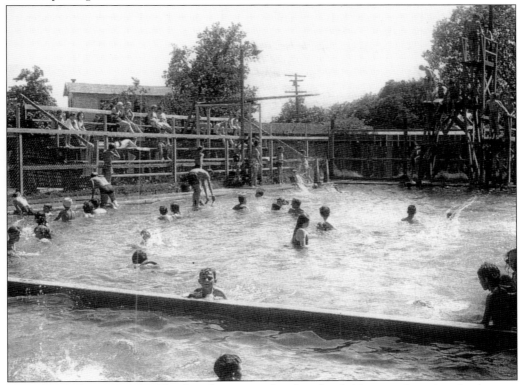

The Johnson Swimming Pool has long been a popular place for children to take swimming lessons, or simply hang out on a hot afternoon. Before chlorine filtration, the pool would be emptied and refilled each night for sanitation. The valves were turned to empty the untreated water into Dry Creek. Then a worker at the ice plant would direct water from the PFE well to refill the pool.

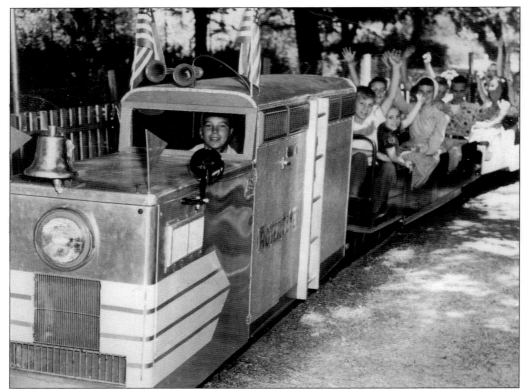

Roseville children loved to spend the day at Royer Park riding the "Little Lulu" train. The park is located alongside Dry Creek on land deeded to the City of Roseville in 1917 by M. J. "Joe" Royer. The train was most likely named after Royer's mother-in-law, Lulu Lohse.

For many years, Royer Park had a zoo with monkeys, a fox, raccoons, rabbits, birds, and bears. Bruin, seen here in 1957, always enjoyed visitors, who were allowed to feed the black bear goodies that would slide down a large pipe for him to snack on. Brutis and Ursela, also black bears, lived 18 years in Roseville before being relocated to Folsom Zoo after the 1995 flood.

Deer were commonly seen in Roseville as late as the 1950s. In the 1960s, a deer park opened near the zoo in Royer Park. Here mountain sheep and deer were protected. The wall in the background of this image, from the Roseville Ice and Beverage Company, remains on the old Royer property today. It can be seen from the park, across the creek where the Public Safety Building and the library on Taylor Street are located today.

Families and schools celebrated May Day at Royer Park every year. One of the events the children looked forward to was the mock bullfight, shown here. Maypole dancing was also a favorite event because every child had a chance to participate.

Roseville wanted and needed a municipal hospital. The closest hospitals were a long ride away in Auburn or Sacramento. Three benefit dances were held in February 1945 to raise the funds to start the project. In March 1952, construction began on Roseville Community Hospital. The doors opened on November 2, 1952, for the citizens of Roseville to tour the 26-bed facility. Now Roseville's babies could be delivered in a hospital.

Hemphill and Leahy were awarded the town's electrical and water franchises in 1906. Wallace Hemphill built his home on Jones Street in 1909. It was family-owned until 1936. Located on the corner of Jones and Grove Streets, it has been the Victorian since 1999, with a changed address: 315 Washington Boulevard. Many weddings and memorable events are held in the 100-year-old Victorian, also known as the Hemphill House.

When automobiles became the rage, Walter Hanisch was the first in town to have one. Born in 1883 in Roseville, he stayed to leave his mark with two full-time, lifelong careers: working in the Roseville Home Telephone Company, and firefighting. This latter career lasted 55 years.

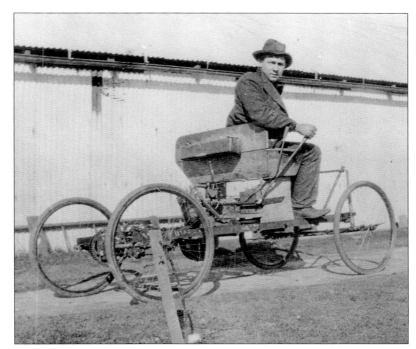

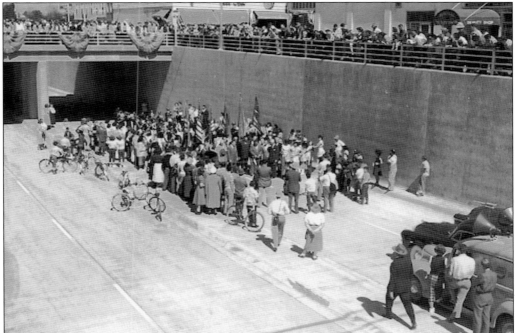

In Roseville, Lincoln Street was once part of State Highway 99. After frequent complaints from travelers irritated by the long wait at the Lincoln Street crossing, the state made plans in 1947 to move the highway under the railroad tracks. Construction crews started to make an underpass for Washington Boulevard between Oak and Church Streets. On April 1, 1949, the Seawell Underpass was dedicated with great fanfare.

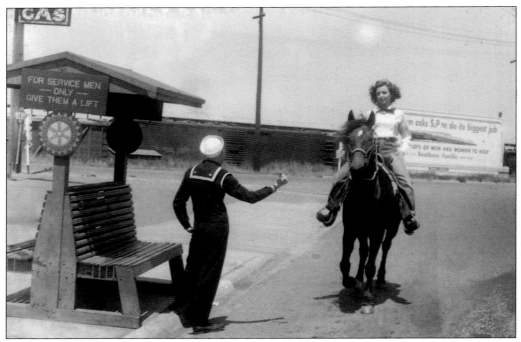

Roseville has always honored those who serve in the military. During World War II, special benches were placed along State Highway 99 and U.S. Highway 40 for servicemen awaiting a ride. As shown here, sometimes the ride was not from a car or bus.

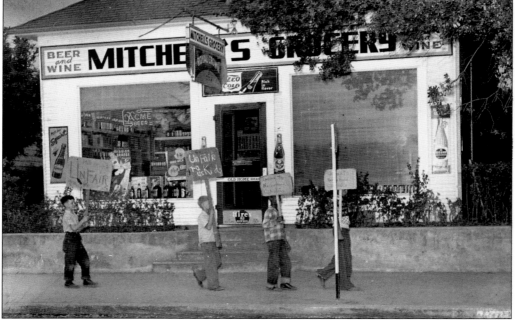

It seems that labor unions are not the only ones who can form a picket line. Unhappy with the treatment they received at Mitchell's Grocery, these young men decided to let everyone know their feelings. Some things never change.

Seven

BUSINESS

NOTHING VENTURED, NOTHING GAINED

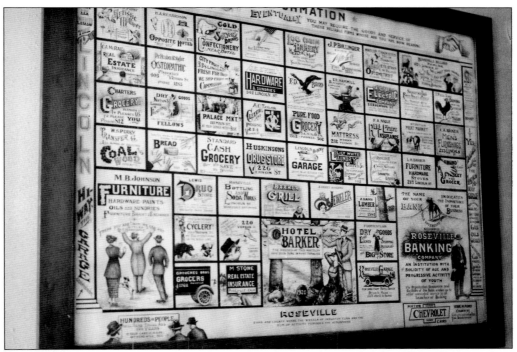

From the earliest days, when pioneer families were just getting settled, businesses began to form a town. The general mercantile stores, blacksmith shops, hotels, repair shops, and many other businesses provided the necessities that would have been needed to survive, work the land, and raise a family. This advertising poster shows some of the businesses that were on both sides of the railroad tracks in 1920.

Roseville's first bank wasn't even a bank building. It was the Holt brothers, working from their house near town. They had struck it rich in the gold mines before coming to settle in Roseville, and became the town's unofficial bankers, financing new business ventures and loaning to those struggling to stay afloat.

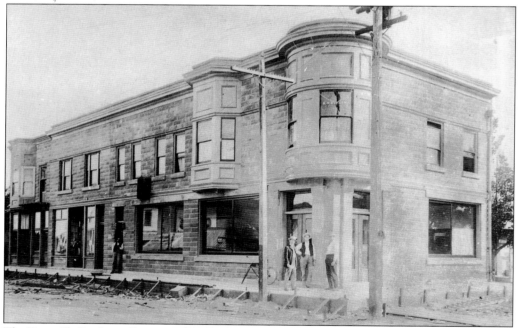

The Roseville Banking Company (RBC), shown under construction here in 1907, was built on the corner of Lincoln and Church Streets. The Clark family relocated their house to Sierra Vista Park to make way for this auspicious two-storied brick building. The RBC, Roseville's first official bank, was originally located on the first floor of what had been Branstetter Hall on Pacific Street.

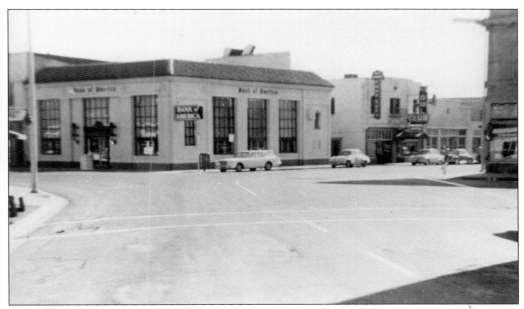

In 1926, the Bank of Italy acquired the Roseville Banking Company. The following year, the building on "Bank Corner" was removed for a new structure, which remains standing on Lincoln Street today. The Bank of Italy later became the Bank of America, pictured here in 1961. Bank of America moved in 1966 to a new building on Vernon Street, which since 1987 has housed Roseville City Hall.

Citizens Bank of Roseville, organized by M. J. Royer, opened for business in June 1930 at 201 Vernon Street. Like many other family homes, the Keehner house was moved in 1921 from the corner of Vernon and Lincoln Streets, as the south side of the tracks became Roseville's business center. The two-story Forlow building was built in its place in 1923 to accommodate businesses and upstairs rentals.

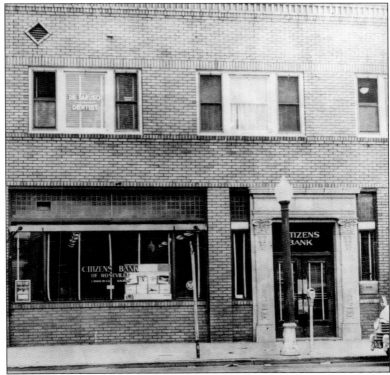

William Alexander Thomas opened the first store in Roseville, in 1865, on the Atlantic and Lincoln Street corner. Thomas, first of the "Big Three" in Roseville's economic development, had everything one could want in his first-floor mercantile store. It included a bakery, hardware (from ten-penny nails to a plow), and the town's first post office. The second floor was a rooming house. Thomas (also called "Uncle Billy") built a wagon and carriage shop nearby.

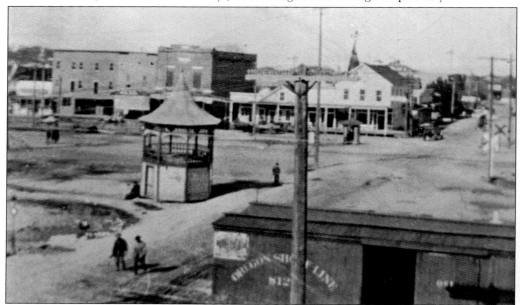

The Lincoln Street railroad crossing marked the entrance to Roseville's northside business district, shown here in 1909. The white two-storied building on the corner of Pacific and Lincoln Streets was built in 1869 by J. D. Pratt, second of the "Big Three," as Roseville's second store. Pratt built the first floor of the brick building to the left in 1878, and sold the airspace above it to the Odd Fellows, who built the upper floors.

The third of the "Big Three" in the business development of Roseville was William J. Branstetter. In 1870, Branstetter first built the Golden Eagle Saloon and Lodging House on Atlantic Street. In 1873, he built the Branstetter Store, home of Roseville's first telephone, on Pacific and Washington Streets. The first floor was a mercantile store, while the second floor was a public hall where the town's social events took place.

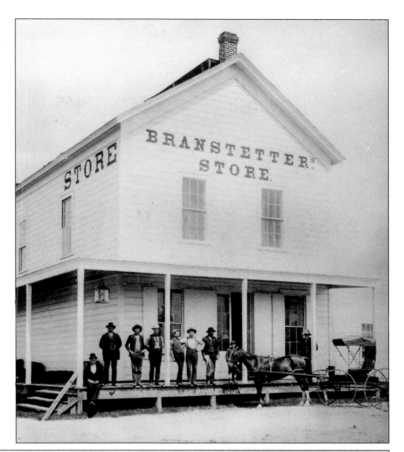

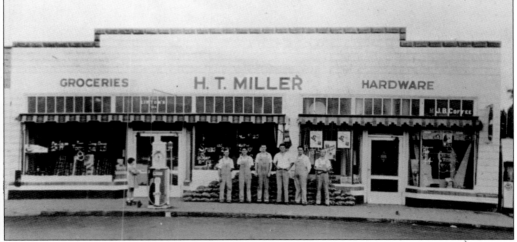

Holcolm Tilden "H. T." Miller opened his first grocery store in 1913. In 1915 he relocated his business to 515 Vernon Street, and after the building burned, he rebuilt out of concrete and reopened in 1925. The family-owned business eventually became Miller's Furniture and Appliance, with two locations. H. T. was also a civic leader, serving on city council from 1926 to 1937, spending two years as Roseville's mayor, and serving on the educational board.

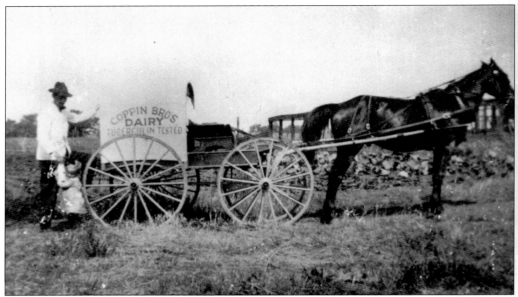

Samuel Coppin started a cattle ranch and dairy business in 1860. The Coppin brothers found that selling milk from the ranch was a good business. Many families, lacking transportation, depended on their home-delivered milk and eggs. After 20 years, the Coppin Ranch was sold and the family moved into town.

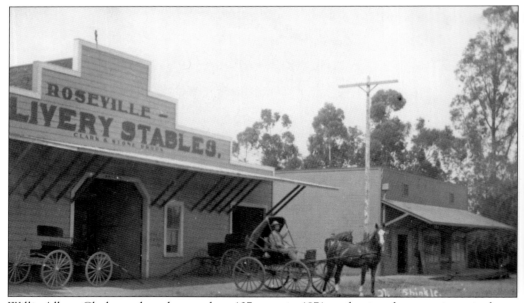

Willis Albert Clark purchased more than 137 acres in 1871, and enjoyed success in agriculture, cattle, and breeding thoroughbred horses. The Roseville Livery Stables were established in 1907 by W. A. Clark and Howard Stone and were successful until 1917, when automobiles rolled into town. The site became a Ford dealership operated by the Saugstad brothers in 1924, and later became the parking lot for the City Annex building.

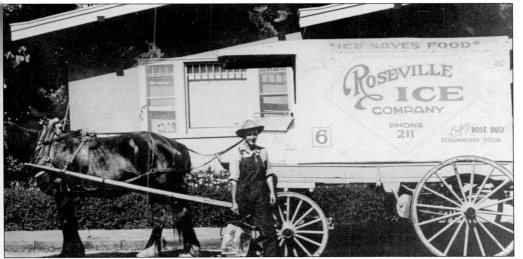

Michael J. "Joe" Royer started a dairy business in 1914, and by 1920 started home ice delivery. The young driver would lug the ice block, using tongs, into the customers' ice boxes, who knew the truth of Royer's slogan, "Ice Saves Food." The Roseville Ice and Beverage Company was built on the old Placer Winery site in 1922 by Royer in partnership with Albert Wolf Sr. and Goff W. Lohse. It closed in 1946.

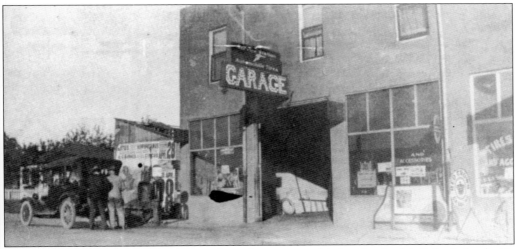

Tony Albert Mealia left school in seventh grade to support his family after his father's death. He worked in a livery stable and trained in bicycle and automobile repair. After serving in the Army, and a partnership in the Lincoln Highway Garage, he opened TAM Garage at 428 Lincoln Street, pictured here in 1924. Mealia served in the Roseville Fire Department for more than 50 years as a volunteer firefighter, and at one time, as fire chief.

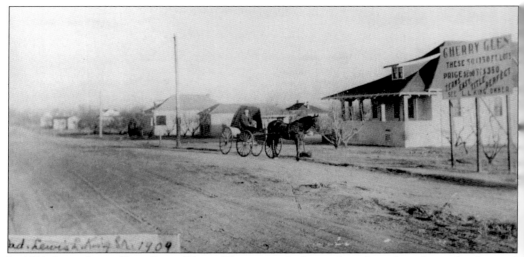

In 1891, Lewis Leroy King Sr. and Jessie Blair opened what is thought to have been the first real estate and insurance office in town. This 1909 photograph of King Sr. shows the Cherry Glen housing development, which was subdivided from the Kings' cherry orchard. The alleys in the area have been named after varieties of cherries grown on the King ranch.

The Porter House, built by DeWitt Porter in 1908, stood at 317 Atlantic Street. The upper floor was the rooming house, while downstairs was a restaurant and barbershop. The rooming house was popular with bachelor railroad workers. Porter sold the building in 1931. It was damaged by fire in 1942, and completely destroyed by fire a year later.

Permission was granted in 1886 by the Odd Fellows and J. D. Pratt to build a new structure using the west wall of their building. The Model Saloon and Café moved in, but the popular watering hole soon became the Up To Date Saloon, seen in this photograph. Patrons of the numerous saloons around town were unhappy with the Sunday Law, established in 1881, which permitted no alcohol sales on the Sabbath.

The Old Depot Saloon, below, was built in 1907 at 319 Atlantic Street from a portion of the dismantled depot building. With no shortage of saloons in the area of the railroad tracks, on the 19th of each month, when "payday" rolled around, there were many intoxicated railroad workers. With no less than 12 and as many as 20 drinking emporiums doing business along Pacific Street, it became known as "Whiskey Row."

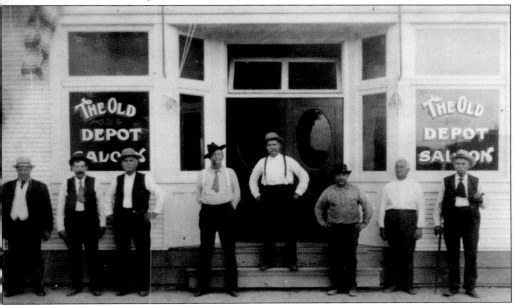

William T. Butler Jr. built and operated four different butcher shops in Roseville between 1894 and 1940. Butler was forced to build a new Butler's Market when Atlantic Street was moved for railroad construction. His new building on the corner of Lincoln and the new Atlantic Street was later rebuilt as a two-story building and was partly a meat market and partly the new post office. Butler's last shop, at 105 Main Street, was open from 1930 to 1976.

Iwasaki Grocery Store at 508 Church Street flourished for many years. George Iwasaki and his family ran a general merchandise store that carried groceries, dry goods, work clothes, and shoes. The Roundhouse Deli now occupies this building in Old Town Roseville.

H. R. Otwell's Store stood at 204 Riverside Avenue as the only business around in 1914. Kids were always welcomed, and loved to get an ice cream or candy from Otwell. A 1922 store advertisement boasted of not only groceries, fresh fruits, and vegetables, but also of home delivery. Carmelita's Restaurant, built in 1962 on the old store site, is a new Roseville favorite.

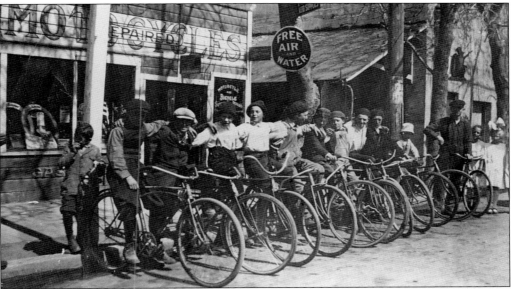

Nevada Carson Jr. operated N. C. Busby Bicycle Shop, a shoe shop, and opened a motorcycle repair shop on 410 Vernon Street, pictured here in 1907. He was nephew and namesake of the N. C. Busby who built the Busby Rooming House and Superior Garage. Having lost both of his legs, the enterprising Busby Jr. got around in a special hand-operated cart.

Berry News Stand was a popular place in the 1920s, 1930s, and 1940s for kids trying to sell some magazines around the neighborhood to earn some spending money. John Hammer Berry would give any kid who asked his first taste of working for pay. His small business started in 1918 as a gathering place where locals could buy a newspaper and see an old friend. By 1922 it was moved to a more spacious two-story building at 228 Vernon Street. Berry continued in business until 1944.

Jensen's Cigar Store, located on Vernon Street, was the place where gentlemen would go to get away for awhile. A favorite cigar or most any kind of tobacco product was available, and neighbors could enjoy a smoke and visit together. Jensen's also sold a variety of magazines and newspapers.

Opening day for the new Roseville Aero Service at Dunbar Field in 1945 was a big day for Roseville. The airfield remained open until January 1950, when the property just north of Denio's Farmer's Market and Auction was sold to build the Tumbling Hills housing subdivision.

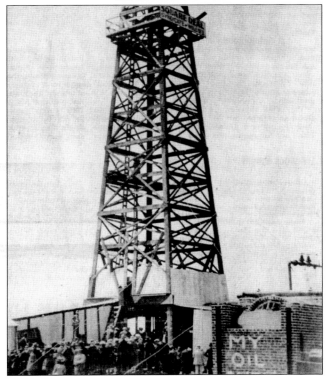

The Sacramento Oil Company and several Roseville residents had high hopes that they would strike it rich in oil. A 114-foot derrick was erected in the 1920s. Initial drilling showed a small amount of oil, but alas, no more was forthcoming. The company moved on and the farmers got back to working the ranch.

On April 2, 1909, 300 residents voted in an election to incorporate the City of Roseville. After almost 150 years of history, since recording the town in 1864, the community still features a hometown atmosphere, even as it has become one of the fastest-growing cities in California. During its 2009 centennial festivities, Roseville celebrated where it has been and where it hopes to go in the next 100 years. The city was given the honor of participating in the 2009 Pasadena Rose Parade. On January 1, the float titled "Entertaining Dreams for a Century" entered the parade procession, loaded with city council members and selected city residents. Everything depicted on the vehicle honored life in the Roseville area, beginning with its flora and fauna, its earliest residents, and the railroad that helped form today's Roseville. Fittingly, in Roseville's 100th year, the town not only participated in the Rose Parade, but was awarded the Governor's Trophy for best depiction of life in California.

ROSEVILLE LANDMARKS

www.arcadiapublishing.com

Discover books about the town where you grew up, the cities where your friends and families live, the town where your parents met, or even that retirement spot you've been dreaming about. Our Web site provides history lovers with exclusive deals, advanced notification about new titles, e-mail alerts of author events, and much more.

MADE IN THE USA

Arcadia Publishing, the leading local history publisher in the United States, is committed to making history accessible and meaningful through publishing books that celebrate and preserve the heritage of America's people and places. Consistent with our mission to preserve history on a local level, this book was printed in South Carolina on American-made paper and manufactured entirely in the United States.

This book carries the accredited Forest Stewardship Council (FSC) label and is printed on 100 percent FSC-certified paper. Products carrying the FSC label are independently certified to assure consumers that they come from forests that are managed to meet the social, economic, and ecological needs of present and future generations.

FSC
Mixed Sources
Product group from well-managed forests and other controlled sources

Cert no. SW-COC-001530
www.fsc.org
© 1996 Forest Stewardship Council

Find Your Place in History.